Managers of the Arts

Managers
of the Arts

Careers and opinions of senior administrators
of U.S. art museums, symphony orchestras,
resident theaters, and local arts agencies.

Paul DiMaggio

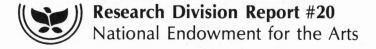 **Research Division Report #20**
National Endowment for the Arts

Seven Locks Press
Publishers
Washington, D.C./Cabin John, Md.

48487

Managers of the Arts is Report # 20 in a series on matters of interest to the arts community commissioned by the Research Division of the National Endowment for the Arts.

Library of Congress Cataloging-in-Publication Data

DiMaggio, Paul.
 Managers of the arts.

 (Research Division report; no. 20)
 "Published for the National Endowment for the Arts."
 Includes index.
 1. Arts administrators—United States. 2. Arts surveys—United States.
I. National Endowment for the Arts. II. Title. III. Series: Research Division
report (National Endowment for the Arts. Research Division); 20.
NX765.D56 1987 700'.92'2 87-9719

 ISBN 0-932020-50-X (pbk.)

Supported by the National Endowment for the Arts, Research Division,
under Grant NEA-02-4050-001.

Edited by Jane Gold

Designed by Dan Thomas

Printed by Thomson-Shore, Inc., Dexter, Michigan

Manufactured in the United States of America

Second edition, April 1988

Seven Locks Press

Publishers
P.O. Box 27
Cabin John, Maryland 20818
301-320-2130

Contents

Introduction

America's first arts organizations were founded in simpler times. When Henry Lee Higginson established the Boston Symphony Orchestra in 1881, its business affairs could be handled by a single paid manager, amply advised by Higginson himself. Approximately one mile from the orchestra's offices, the new Boston Museum of Fine Arts was also managed by a skeleton crew, with trustees doing most of the work. Even in the 1950s, when the resident theater movement began to grow, most theaters were administered by their charismatic founders during moments stolen from artistic duties. In all these settings, the key personnel were experts in the artistic work at the core of their organizations' missions. For many years, conductors, curators, and artistic directors were undisputedly the most visible and most important members of the institutional art world.

During the last two decades, however, full-time administrative roles have become more prominent in America's arts organizations, and their functions have become more formalized. Two factors have led to this development: the internal growth of the organization and the increased complexity of its external environment.

It is a staple of management literature that growth leads to differentiation, and differentiation increases the demands on administrators.[1] As organizations grow, they assume more tasks and need more employees to perform the tasks they already have. As the numbers of tasks and employees increase, functions that had been carried out by a single person are delegated to additional personnel, who may eventually be designated as a discrete department. (In theaters, for example, artistic directors begat managing directors who begat marketing, development, and public relations staffs.) The more employees and departments, the harder to coordinate their activities. (The artistic director of the 1950s may have had a difficult time handling his theater's administrative chores, but at least his right hand knew what his left hand was doing.) Consequently, management becomes more essential.

In addition, as the external environments of many arts organizations become more complex, the amount and importance of managerial work also increase.[2] The museum director of the 1930s had only to manage his curators and volunteers, pursue collectors, and, if the museum benefited from municipal funds, court an occasional politician. The museum director of the 1980s seeks support not just from private patrons, but from corporations, private foundations, and the state and federal governments as well. To maintain legitimacy in their eyes, the director must be more concerned than ever before both with the museum's public image and success in attracting visitors, and with its ability to produce reasonably complete and auditable accounts that meet the requirements public and private agencies impose. Consequently, museums today are more likely than those in the past to have an assistant or associate director for administration, a controller, and departments like marketing, public relations, development, and government relations that concern themselves with the museum's relationships with its environment; and museum directors today devote more time to administration and public relations and less time to scholarship than did their predecessors.

These changes have been widely acknowledged. Interviews with the chief executive and operating officers of arts organizations suggest that most arts organizations' boards have become increasingly concerned with the quality of administration. Service organizations have established internships, workshops, and other training programs to prepare and assist administrators. The National Endowment for the Arts, through its "Services to the Field" funding categories, has aided many efforts to improve administration, and many state arts agencies sponsor extensive technical assistance programs. Private foundations have supported workshops, conferences, and arts administration degree programs, as well.

But despite this activity, we have known little about the *individuals* who occupy the top administrative posts in our nation's arts organizations. Until now, research in this area has been restricted primarily to salary studies. Such research is valuable, of course, but it tells us little about either executive labor markets in the arts or the executives themselves—their backgrounds and training, their careers, and their attitudes on management and policy issues.

Methodology and Design

The research presented in this report was conducted to provide practitioners, donors, and policymakers with information on the administrators of four kinds of arts organizations: resident theaters, art museums, symphony orchestras, and community arts agencies (CAAs).[3]

In 1981, survey instruments were mailed to the chief operating officers (identified by initial phone calls to the target organizations) of four populations of arts organizations, with requests that they be completed and returned. These were followed by a second mailing, also including a survey form, and, where necessary, by a follow-up postcard and by one or more telephone calls. Each survey instrument was reviewed by at least one National Endowment for the Arts program staff member and at least one staff person at the appropriate service organization.

Although we sought to survey top managers of the major organizations in each of the fields studied, the population definition differed somewhat among the four. The resident theater population consisted of managing directors of the 165 member resident theaters listed in *Theatre Profiles 4* of the Theatre Communications Group. Wherever a resident theater had both an "executive producer" and a "general manager," the producer was surveyed,[4] as were several artistic directors who also acted as managing directors for their theaters. In one case in which a theater was managed collectively by its artistic personnel, no survey was administered.

The 165 theaters surveyed included all or almost all of the largest resident theaters in the United States, as well as most of the artistically prominent ones, the membership of the League of Resident Theaters, and all 29 theaters listed as having staff on the National Endowment for the Arts' Theater Policy and Grants panels from 1977 through 1979. In addition, these theaters received approximately 80 percent of all Endowment grants to theaters in 1979. Although one study of the nonprofit theater universe counted 620 nonprofit theaters in the United States in 1980, only some were resident theaters.[5] Of those, the group surveyed was less likely to include very new, very small, or very poor theaters, or theaters devoted largely to social rather than to conventionally defined aesthetic goals.

In the case of orchestras, we surveyed all managers of U.S. member organizations in the major, regional, and metropolitan categories of the American Symphony Orchestra League (ASOL). Interviews indicated that all orchestras in the "major" and "regional" categories and 95 of approximately 105 orchestras in its "metropolitan" budget range were ASOL members. (These three categories accounted for 156 organizations in 1979.)[6]

Because the American Association of Museums (AAM) does not publish lists of art (as distinct from other) museums, identifying the largest art museums was more complicated than identifying major resident theaters and orchestras. From the National Center for Educational Statistics (NCES) 1978 Museum Universe Survey[7] we drew up an initial list of 137 art museums with operating budgets of $120,000 or more, to which we added art museums reporting either attendance of 60,000 or more, or a total budget

of $220,000 or more.[8] This list was then checked against the *Museum Directory 1980* to screen out museums incorrectly classified as art museums,[9] and to the remaining 175 institutions we added 17 that were not included in the NCES list: 13 art museums that reported budgets of $500,000 or more in the 1978 *American Art Directory*, and 4 whose directors were members of the Association of Art Museum Directors (AAMD).[10] The total population of large art museums thus derived numbered 192.

To develop a list of CAAs, we began with a survey made by the National Assembly of Community Arts Agencies (NACAA)(now the National Assembly of Local Arts Agencies) of their own membership. NACAA estimated the universe of CAAs to number approximately 2000. Directors of all agencies reporting a full-time professional administrator in response to the NACAA inquiry were included in our study's population. Although we cannot assess rigorously the extent to which the agencies in our population differed from those that were not NACAA members and/or those without full-time paid administrators, our agencies were probably larger or wealthier than most (because they could afford to employ full-time directors) and were relatively cosmopolitan (because they participated in a national organization). Nonetheless, our findings regarding CAA directors should be interpreted with caution since we know so little about the universe of agencies.

After we eliminated organizations that were defunct or that did not, at the time of the survey, have full-time executives, we were left with responses from 102 theater managing directors (a response rate of 68.67 percent), 113 orchestra managers (72.67 percent), 132 art museum directors (67.20 percent), and 171 CAA directors (86.54 percent).

Merging our data with information from *Theatre Profiles 4* permitted us to test the sample of resident theater managing directors on a variety of factors for response bias. These tests revealed that respondents' and nonrespondents' theaters were similar across a wide range of variables, including region, house capacity and percentage of seats filled, percentage of income earned, and mean income.

Among art museum directors, only museum region could be used to test for response bias. Response was somewhat higher for directors from the Great Lakes, Mid-South, and Gulf regions (74.19 percent) than for directors from the Pacific, Northwest, Southwest, North Plains, and South Plains regions (60.00), with the response rate of directors from New England, the Middle Atlantic states, and New York close to the population mean.

Response rates of orchestra managers varied not by region but by ASOL budget classification. Almost all of the regional managers responded to the survey, compared with just under two thirds of the metropolitan managers. Response from major managers was close to the population mean.

Lastly, for CAA directors, our survey was merged with data from NACAA's 1980 survey (from which our sample was derived), providing several tests of sample bias. Response rates were very similar by region, degree of urbanization of community served, and budget size; however, directors of private, undesignated nonprofit agencies were less likely to respond (78.13 percent) than were directors of either publicly designated nonprofit agencies or public CAAs (90.32 percent and 92.11 percent, respectively).

Because none of the surveys, then, appears to be flawed by dramatic response bias, given the qualifications cited and the relatively high response rates, analyses can, for the most part, be generalized to the populations surveyed.

Still, certain caveats should be observed in interpreting the data presented in the following chapters. First, the findings cannot be generalized *beyond* the populations surveyed: in the case of the theaters, orchestras, and art museums, they apply only to executives of the 150 to 200 major institutions in each field; and, in the case of the CAAs, they apply only to those NACAA members who indicated they had a full-time paid director. This is not a major disability, however, because the organizations surveyed account for the great bulk of expenditures in their fields, and many smaller organizations do not have full-time paid managers.

In a few cases, particularly in the survey of theater managing directors, substantial item nonresponse rendered interpretation of specific results difficult. All tables indicate the number of respondents on which results are based, and the most striking instances of item nonresponse are mentioned in text or notes. Other caveats apply only to specific chapters and are described at length in the text.

The Report

This report first examines the backgrounds, schooling, and career experiences of the senior administrators surveyed; the preparation they had for their positions and their evaluations of it; and the rewards and satisfactions they receive from their jobs and their expectations for future employment. It then addresses the extent of the administrators' participation in professional activities outside their organizations, and lastly it reviews their attitudes toward a range of policy and management issues, many of which relate to their organizations' missions. In each chapter, we first compare the responses of administrators *from* each field; and then, based on factors such as cohort, organization size, and career experience, we look at notable variation in responses *within* each field.

The material in this report represents the major findings of this study.

For the sake of brevity, reports of many analyses have been omitted. A much longer, more exhaustive report of our findings, including copies of the survey instruments and of all tables for which statistics are cited, is available for study at the offices of the National Endowment for the Arts' Research Division. This report has been distributed by the Educational Research Information Center (ERIC) to libraries and to "on-line" commercial information services under the title *The Careers and Opinions of Administrators of U.S. Art Museums, Resident Theatres, Orchestras, and Local Arts Agencies* (ERIC No. ED 257 696).

The author is obliged to many people and organizations for help in undertaking and completing this study. In addition to the Research Division of the National Endowment for the Arts, the Yale University Program on Non-Profit Organizations provided financial backing and a supportive environment for this research, and data analyses were supported by Yale University through the Institution for Social and Policy Studies, School of Organization and Management, and Department of Sociology. I am particularly grateful to Prof. John G. Simon for his confidence in this work. Time to revise the report for publication was provided by a sabbatical from Yale, which was supported by grants from the Carnegie Corporation of New York and the William and Flora Hewlett Foundation to the Yale Program on Non-Profit Organizations; and by a grant to the Center for Advanced Study in the Behavioral Sciences from the Andrew W. Mellon Foundation. The Center for Advanced Study provided expert clerical and computer assistance and a nurturant atmosphere without parallel.

The largest debt of appreciation is owed to the many administrators who took time from their usually oversaturated schedules, often with extraordinary good humor, to complete the surveys. Many arts administrators, service organization staff, and staff of public arts agencies, some of whom would prefer to remain unnamed, provided invaluable critical reviews of draft survey instruments. I am grateful for the help and cooperation of the NACAA, and in particular, of its directors, Chick Dombach and Gretchen Weist, who kindly made available to me results of their own survey of NACAA's membership. The good counsel and patience of Tom Bradshaw, Harold Horowitz, and John Shaffer of the National Endowment for the Arts' Research Division, is much appreciated, as is advice on survey drafting from several present and former Yale colleagues, especially John Kimberly, Walter Powell, and Janet Weiss. Mitchell Smith of the New York State Council on the Arts offered helpful tips on surveying arts administrators. Ella Sandor of the Yale Program on Non-Profit Organizations facilitated the administration of the study throughout, and Barbara Mulligan and Marilyn Mandell provided outstanding clerical (and, at time, more than clerical) assistance during the survey phase. Thanks is due Caroline Watts,

Elizabeth Huntley, and Naomi Rutenberg for dedicated research assistance in undertaking the survey; Frank P. Romo, for advice on data analysis; and, especially, Kristen Stenberg, for superb assistance in data analysis and for extraordinary feats of diligence, patience, and creativity in data management.

Notes

1. Peter M. Blau and Richard A. Schoenherr, *The Structure of Organizations* (New York: Basic Books, 1971).
2. This argument is made most lucidly by Richard A. Peterson in "From Impresario to Arts Administrator: Formal Accountability in Nonprofit Cultural Organizations," in *Nonprofit Enterprise in the Arts: Studies in Mission and Constraint*, ed. Paul DiMaggio (New York: Oxford University Press, 1986).
3. When this research was undertaken, "community arts agencies" was the term commonly used for organizations that now refer to themselves as "local arts agencies." The service organization for this field, the National Assembly of Local Arts Agencies (NALAA), was then named the National Assembly of Community Arts Agencies (NACAA). Throughout this report, the term "community arts agency" (CAA) is used to refer to the agencies at the time of the survey, while "local arts agency" is used as the generic or contemporary reference.
4. David J. Skal, ed., *Theatre Profiles 4* (New York: Theatre Communications Group, 1979).
5. Mathtech, Inc., *Conditions and Needs of the Professional American Theatre* (Washington, D.C.: National Endowment for the Arts, Research Division, 1980).
6. *Resource Guide* (Vienna, Va.: American Symphony Orchestra League, 1979).
7. See Macro Systems, Inc., *Contractor's Report: Museum Program Survey, 1979* (Washington, D.C.: National Center for Educational Statistics, 1981).
8. Some responding museums provided only "total budget" figures rather than "operating budget" information. Where attendance reports appeared inflated—i.e., where they were inconsistent with data on budget and hours—museums were dropped.
9. American Association of Museums, *The Official Museum Directory 1980* (Skokie, Ill.: National Register Publishing Co., Inc., 1979).
10. Jacques Cattell Press, *American Art Directory* (New York: Bowker 1980).

Executive Summary

This survey report examines the backgrounds and careers of senior administrators of resident theaters, art museums, symphony orchestras, and community arts agencies (CAAs); the rewards they receive from their work and their expectations about future employment; the training they have had and their evaluation of it; and their professional participation and attitudes on a range of management and policy issues. Highlights of the study's findings are summarized under three headings, each a topic of importance to arts administrators and policymakers: recruitment and reward, training, and professionalism.

Recruitment and Reward

The 1960s and 1970s were a time of expansion for the arts in two senses: first, many arts organizations grew significantly in size during that period; and second, the number of organizations in many fields grew substantially as well. Growth of both kinds increased employment opportunities, attracted potential managers into the labor market, and provided rapid advancement for many of the people thus drawn in. But if growth slows down in the years to come, arts organizations may find it more difficult to recruit managers; and managers, once recruited, may find fewer opportunities for career development than did their predecessors.

Indeed, in 1981, when these data were collected, the years in which the managers surveyed had entered their fields tended to cluster for all disciplines but orchestras. The greatest period of influx among art museum directors was between 1966 and 1970; among theater managing directors, between 1971 and 1975; and among CAA directors, between 1975 and 1979. These periods occurred either during or immediately after expansionary eras.

1

Most administrators came from relatively—but not extremely—privileged social backgrounds. Their parents had more years of schooling and better jobs than most Americans of their age. However, except perhaps for those of the art museum directors, administrators' parents were not predominantly college educated, professional, or upper managerial. Cohort comparisons indicate that, among art museum and, to a lesser extent, theater administrators, family backgrounds have become less high-status over time.

By contrast, the administrators themselves were notably well educated. In every field, all but a few had college degrees and more than half pursued their formal education beyond college. Greater educational attainment over time was found among theater managing directors and art museum directors, the latter of whom increasingly had earned Ph.D.s in art history; and substantial percentages within both groups with college degrees had earned them at very selective colleges and universities.

At the same time, women in all fields tended to have received fewer years of education. They also managed smaller organizations. But although all fields except the art museums had greater percentages of women among more recent cohorts of administrators, we cannot assume their greater representation indicates a long-term expansion of opportunities for women administrators since the attrition of women managers may possibly be higher than that of their male counterparts.

Administrators were initially recruited into their fields from various sources. About 40 percent of the art museum directors and orchestra managers entered their fields immediately after completing their formal education. This proportion declined among theater managing directors and was even smaller among CAA directors. However, only in the symphony orchestra field were administrators frequently recruited from business enterprises.

The first jobs many respondents held in their fields (as many as 80 percent of CAA directors) were top administratorships. Smaller proportions in each field entered into aesthetic positions first, from theater managing directors and orchestra managers who began as actors or musicians, respectively, to art museum directors who started in curatorial, registration, or exhibition positions.

Nonetheless, many administrators did have firsthand familiarity with the arts they managed. Approximately 20 percent of the orchestra respondents had worked at some time as musicians; a similar percentage of the CAA directors reported working as visual or performing artists; two fifths of the theater managing directors had been actors or artistic directors (not necessarily full time); and more than two fifths of the art museum directors had been curators. What is more, substantial percentages of top managers in each field majored in a relevant artistic discipline in college.

2

In the performing arts, however, our 1981 data show that the percentage of administrators with artistic experience appears to have declined over time: the most recent entrants into these fields were more likely to have administrative experience and/or management degrees, and were less likely to report artistic experience, than were more senior administrators. Similarly, the percentage of art museum directors who had been curators declined with time as the percentage of new recruits moving to directorships from academic teaching jobs increased.

Arts administration careers lack the formal structure that educational and internship requirements impose on the traditional professions and that managers of the largest corporations receive from internal labor markets. There are no formal ranks or systematic evaluations as there are in government service to provide individuals with guides to their own progress. Indeed, only in the art museums, where one career pattern (from curator to director) was being preempted by another (from art history professor to director) were there one or two modal career progressions. In the other fields, and particularly in the community arts, careers were neither routinized nor predictable.

Such unpredictable career structures are often stressful, and where careers are sufficiently chaotic, retention of personnel may be difficult. To some extent, expansion of members and size of organizations may have softened the effects of a lack of routinization between 1960 and 1980, during which time administrators in all four fields rose quickly to commanding positions. Median years to first top managership range from zero among the community arts respondents (where most directors were hired into top positions from outside the field) to about six years in the art museum field. Most administrators attained their first chief executive positions while still in their thirties. Contrary to popular belief, however, arts administrators who remain in their fields do not appear to be job-hoppers: more than half of those surveyed had worked for one or two organizations in their fields, and only a small percentage had held jobs at more than four.

To the extent that the rate of growth of the field covered in the study (and with it opportunities for career advancement) has declined during the 1980s, arts organizations may have trouble recruiting and, in particular, keeping talented administrators. It is thus all the more important to understand the rewards that keep administrators at their jobs.

Organizational budgets and salaries were highest for the art museums and orchestras, and lowest for the resident theaters and CAAs. Art museum directors and orchestra managers also reported somewhat higher levels of satisfaction than did other administrators. By contrast, more CAA directors than other respondents considered it likely that they would accept a job outside the arts, that they would work for public arts agencies other

than CAAs, or that they would manage some other kind of arts organization. These findings suggest that the lack of both resources and other more subjective rewards may lead to attrition among CAA directors and perhaps among administrators in other fields as well.

Holding other factors constant, seniority was related to the size of organizational budget in all fields but the art museums; it also influenced salaries in all fields but art museums. Thus women, who managed smaller organizations, received lower pay than comparable male administrators in every field. Finally, attendance at a private school or a prestigious college was associated with organizational budget as well. Among art museum directors, the best predictor of the resources a director commanded was possession of a degree from a specific prestigious American university.

Factors that influenced expectations of leaving administrative positions in the arts differed among the four fields. Women theater managing directors, for example, were more likely than their male counterparts to expect to take jobs outside of the arts, as were art museum directors if, controlling for other factors, they had a lot of museum experience for their age and had worked as curators. Orchestra managers with business degrees were less likely, other things equal, to anticipate working outside of the arts than were those without them. And among CAA directors, intention to leave the field was negatively associated with college selectivity and years of experience, and positively associated with parental education. Finally, for all groups but art museum directors, administrators in the middle cohort were most likely to consider their taking a job outside the arts, which perhaps indicates frustration over career blockage among midcareer managers. It is among these midcareer managers and, for the theaters, among female administrators, that the dangers of significant attrition would appear greatest.

These findings suggest the importance of both rewards and relatively stable career paths in recruiting and keeping talented administrators. Of course, some administrators will always be attracted to the arts; those surveyed reported deriving satisfaction from many aspects of their work. Yet it will probably remain difficult—and, to the extent expansion slows, become more difficult—to attract and retain committed and talented administrators in all the fields discussed here, except perhaps art museums. The danger of attrition appears greatest in community arts agencies, where careers are most chaotic and salaries are lowest; conversely, it is least pressing among art museum directors, whose salaries are highest and whose career patterns are most predictable. The data reported suggest that a program aimed at attracting and keeping managers would have to accomplish three things:

1. Raise salaries in fields in which administrators are least well paid.

2. Establish somewhat more predictable career paths that offer the prom-

ise of further opportunities to administrators who reach the top of large or medium-sized organizations relatively early in life.

3. Offer more equal opportunities to women managers who pursue careers in these fields.

Training

As the number and complexity of arts organizations have grown, so has their need for skilled managers. Yet strikingly few of the administrators surveyed reported being well prepared for managerial positions. CAA directors (who, on average, first became administrators at an older age than other managers) were somewhat more likely to be prepared and art museum directors somewhat less likely—to assume many administrative duties at the time they were appointed to their first top managership. In each field, as many reported being poorly prepared for each function as being well prepared. In short, administrators in all four fields believed their preparation, particularly in financial management and labor relations, could have been much better. Additionally, theater managing directors felt they had been poorly prepared for board relations while art museum directors specifically faulted their preparation for government relations, marketing and public relations.

According to their responses in the survey, only the younger theater managing directors had become better prepared for their positions than the more senior managing directors. The more junior cohort among them were more likely than any others to consider themselves well prepared at the start for all functions but labor relations, and less likely to consider themselves poorly prepared for every function but personnel management. By contrast, the senior art museum directors and orchestra managers were more likely to report themselves poorly prepared for everything but personnel management than were directors in the middle cohorts of their fields.

Administrators in all fields responded that on-the-job training was the principal means by which they had tried to master each of the management functions about which they were questioned in the study. Many had used professional workshops and seminars, and art museum and theater managing directors in particular had used consultants. A smaller minority of administrators in each field had taken university arts administration and general management courses—especially theater managing directors and orchestra managers—most notably in the area of financial management; and attendance at these courses, particularly among these groups, seemed to be rising.

General reputations of different training formats were surprisingly consistent from field to field. Respondents in all fields ranked on-the-job training above all other forms, and internships were highly valued as well. By contrast, management consultants were ranked very low in every field.

5

Respondents were most polarized around university arts administration and general management courses, and change in reputation by cohort appeared only among the theater managing directors, where relative newcomers favored university courses over workshops and seminars more than their more senior colleagues did.

Yet when the question specified the management function for which each training format was used and only those respondents who had actually *used* the respective formats were asked to evaluate them, the responses were quite different. Although the reputation of consultants among all administrators was quite low, managers who had used them reported high levels of satisfaction. Conversely, respondents who had used arts administration programs found them relatively unhelpful for most purposes, even though their generalized reputation was rather high.

These findings reflect subjective appraisals and not objective measures of the quality either of the preparation arts administrators received or of the different kinds of training formats. They do, however, suggest several points policymakers should bear in mind:

1. Administrators in all these fields perceive their preparation for executive positions to be inadequate.

2. On-the-job training is still the most common and best appreciated kind of training in every field for administrative skills.

3. People who actually used different training methods for specific purposes rated them differently than those who had not used them. To the extent that the former's evaluations have a sounder basis, program administrators should be cautious of making decisions about training alternatives on those methods' general reputations. Agencies and foundations that have supported the development of specific kinds of management training should consider rigorously evaluating the effectiveness of the programs they have aided before expending more funds for this purpose.

Professionalism

The term *professionalism* is often used to connote competence, and a "professional manager" is often seen as one who is knowledgeable and capable. This usage, however, does not tell us how occupations that are regarded as professions differ from those that are not. (There are, for example, bricklayers, train conductors, and automotive mechanics who are both well and poorly trained, both competent and incompetent; yet few people talk about professionalism in those fields, and those who do are not taken very seriously.)

Instead, this report adheres to a definition of professionalism that is based on a tradition of studies of professionals and professionalizing occupations. In this tradition, professions are described as occupations with some or all of the following characteristics: a monopoly of at least somewhat esoteric knowledge; a body of professional ethics or standards; professional associations that enforce these standards, accredit training institutions, and license practitioners; extensive collegial interaction among practitioners employed in different organizations; a commitment to professional standards even when they conflict with organizational goals; and a claim to altruism and disinterestedness in professional practice. *Professionalism*, as used here, refers to the presence or absence of these factors, and not to the competence or lack thereof of practitioners.

Administrators in all four fields participated in an extensive web of local, state, and national professional activities, ranging from explicitly professional societies like the Association of Art Museum Directors, to service organizations that function in some ways like professional associations, to peer review panels in state and federal arts and cultural agencies. Speeches at association meetings and articles in field publications often refer to professionalism as a goal or a reality.

Yet in none of these fields were managers regarded as professionals as the term is used here. In no case, for example, were practitioners required to hold degrees in a particular management curriculum, nor were they licensed by professional panels. Moreover, allegiance to values associated with professionalism (mastery of a formal body of expertise, support for professional over organizational standards, licensing for practitioners) was far from universal among the respondents.

Possibly these findings reflect processes of professionalization that are still incomplete. Indeed, professionalism seems least advanced among the CAA administrators, the newest managerial group, and most advanced (although in its art-historical rather than administrative sense) among the art museum directors, the arts' oldest administrative cadre. Our survey reveals some evidence of managerial professionalization in the resident theater, where younger managing directors were more likely to have formal training beyond college, management degrees and management experience prior to assuming their first top administrative position, and in-service training in university management programs. Attitudes of the more recent theater administrators were also more akin, in some respects, to traditional professional values than were those of their more senior colleagues. Nonetheless, even the most junior cohort of managing theater directors showed divergence from the professional model, and experiences and attitudes of administrators in the other fields were even less typical of professionalism.

Managerial professionalization in the arts is a movement fraught with paradox. One paradox has to do with the nature of professional management in any field. A tension exists between the emphasis in professional ideology on peer control and the emphasis in management on the pursuit of the organization's best interests. If *the professional*—by definition—must evade organizational control to live up to the standards of the profession, *the manager*—again, by definition—must exert control for the benefit of the organization. If the professional's legitimacy comes from the impossibility of routinizing his or her work, the manager's derives from his or her expertise at making organizational processes more routine. Managerial and professional warrants for occupational authority are different and, to some extent, inconsistent.

A second paradox has to do with tensions between managerial and aesthetic orientation. Within the arts, even among administrators, there is little consensus as to the kind of expertise that should be expected of managers. In some organizations, the manager must master techniques of budgeting, marketing, and public relations. In others, subordinates execute these functions, and the manager is a catalyst and integrator of the work of others. In still others, the administrator deals primarily with the organization's environment, specializing in fund-raising and public relations. In the absence of uniformity in arts organizations' needs, and thus of consensus about what the expert manager should be expert at doing, it is difficult to design a formal curriculum, much less to expect that arts organizations will demand that administrative candidates hold a specific credential. Uncertainty about the nature of managerial work is reflected in the emphasis on hands-on experience that emerged in respondents' criteria for selecting directors and in their evaluation of training approaches.

This uncertainty is compounded by the belief of many (particularly older) administrators in arts organizations that the chief executive should be someone with aesthetic as well as administrative expertise. Among the administrators surveyed here, this was a minority view in all fields but the art museums. Ironically, however, it is the art museum directorship that has professionalized at a faster pace than any of the others. More than half of the most recent cohort of art museum directors held a specialized advanced degree (the Ph.D. in art history)—education appears to have become a more important determinant of success while family background has declined in importance—and they were more likely than other respondents to stress the importance of professional codes of ethics and even to entertain the idea that professional associations should play a role in enforcing such codes. Yet these directors were least likely to have management training or to value a management background. Theirs is a professionalism in which administrative expertise plays only a minor role.

The third paradox involves the underlying structure of managerial careers and the absence of a basis in the labor market for an arts management profession. The labor markets for the fields investigated here (with the important exception of the community arts organizations) appear highly segmented. Few respondents in any field but the community arts had ever been administrators in any other field or anticipated ever managing a different kind of arts organization. Very few art museum directors had ever worked for any other kind of museum, and nearly as few expected ever to work for one, much less to administer some other kind of arts organization. Although many CAA directors had experience in the performing or visual arts, the backgrounds of other administrators suggest that the road from disciplinary organizations to the community arts organizations is a one-way street. What is more, few administrators had degrees in arts administration, and such degrees were not valued as highly as many other kinds of preparation. Thus, it appears that *arts administration* is a term that describes not a single profession but a family of occupations, each with its own labor market.

The issue of professionalism should not, however, obscure the real need of arts organizations for strong management in an increasingly complex environment. Arts organizations in the fields studied here face challenges in recruiting and retaining talented administrators, and in providing the training they need to do their jobs well. The growth in the arts during the 1960s and 1970s may have softened the challenges of getting and keeping competent administrators at the same time that it made their jobs more complicated than they had once been. Slower growth in the years to come could make those challenges even more pressing and could jeopardize the gains in administrative performance that have been achieved.

Policymakers concerned with the need in the future for strong arts management should work toward a better resolution of three paradoxes:

1. Managerial and professional warrants for occupational authority are different and, to some extent, inconsistent.

2. There is little consensus, even among administrators, as to the kind of expertise that should be expected of arts managers.

3. The underlying structure of managerial careers in the four fields studied indicates a family of occupations, each with its own labor market, rather than a single profession.

1

Backgrounds, Recruitment, And Careers

Many of the most critical managerial problems facing American arts institutions concern the careers of the individuals who manage them. An artistic discipline must induce capable managers to enter career paths that lead to executive positions. It must provide these individuals with the experience and knowledge they need to perform effectively as top executives. And it must reward talented executives sufficiently so they will remain in the field.

In short, for a field to attract and retain talented managers, it must provide careers—sequences of jobs that lead to desired end points—to motivate people to participate. Orderly careers allow individuals to compare their progress with that of their peers, to seek proximate goals with some certainty that they will lead to valued long-range outcomes, and to work from day to day with some confidence that competent performance will be rewarded. In fields where careers are chaotic (the paths to higher positions being irregular and unpredictable) or where opportunities are few, it is difficult to attract talented managers or to persuade those who are attracted to stay.

Individuals and service organizations in all artistic disciplines are concerned about administrative recruitment.[1] But, as yet, we have known little about who art managers are: their background, their education, their preparation, and their success (or lack of success) in their chosen fields.[2] Where concern is great and information meager, stereotypes abound. Managerial careers in the arts are said to be characterized by instability and job-hopping. Arts managers are sometimes portrayed as failed artists, frustratedly accepting executive positions for which they are unqualified

11

as substitutes for artistic roles they would rather play. Or, alternatively, arts administrators are alleged to be "just" managers, knowledgeable about accounting and marketing but insensitive to the particular needs and demands of their artistic disciplines. The results of our research, however, suggest that these stereotypes *are not* well-founded.

Educational and Social Backgrounds

Managers in each field were predominantly from upper middle-class backgrounds. Museum and theater managing directors ranked slightly higher on most measures of family status, followed by orchestra managers and then CAA directors; more than one sixth of the CAA directors grew up in blue-collar families, while fewer than one tenth of museum or orchestra top executives did. Accordingly, museum directors were somewhat more likely and CAA directors somewhat less likely than managers in the other two fields to have college-educated fathers and to have attended private schools.

Based on the Astin Index of "College Quality," which measures selectivity as much as it does quality and is used widely by researchers in higher education, museum directors attended more selective colleges and CAA directors less selective colleges than did theater and orchestra managers. Nonetheless, the vast majority of all managers earned a college degree, and more than half in each field (and almost all art museum directors) sought graduate degrees.

While in college, managers majored in artistic fields related to their later employment (e.g., theater studies, art history, music, or visual arts) to a striking extent (from 39 percent of CAA directors to 58 percent of art museum directors), and over one quarter of those who did not chose the humanities—including English literature, history, or foreign languages. Although relatively few managers in any field majored in education, management, or arts administration as undergraduates, a small minority did pursue advanced degrees in management or arts administration. However, many even in that minority hold B.A.s in their field's art form. These facts tend to refute assertions that arts organizations have been taken over by artistically unsophisticated professional managers, at least insofar as we define *professional* in terms of academic credentials.

Differences Between Male and Female Managers
Across the four disciplines, the proportion of top managers who were men varied widely, ranging from 45 percent in CAAs to 85 percent in art museums, with about two thirds in theaters and orchestras. In every field except art museums, however, women disproportionately had less senior-

ity (measured by the year in which they began their first full-time job in the field), even though they were not necessarily younger. For example, although male theater managers were more likely than their female counterparts to be over 40, the opposite was true in CAAs and art museums.

In all fields but theater, female managers tended to come from a higher-status social background than did their male counterparts. Thus, they were more likely to have had college-educated parents—especially mothers—and fathers who were businessmen or professionals, and less likely to have come from blue-collar homes. By contrast, again in every field but theater (where there was little difference), male managers were more highly educated than females, as evidenced by their much greater likelihood of having received graduate training and/or degrees.

While in college, women orchestra and theater managers were from two to four times as likely as men to have majored in the humanities; far fewer women orchestra and CAA managers majored in the performing arts. While female CAA managers who majored in education or the social sciences outnumbered the males, no female theater managers majored in business or arts management, whereas one in seven males did. Within each field, the most striking difference was that women managers tended to administer smaller organizations. For example, more than half of all women art museum directors were in the smallest quarter of museums while just 18 percent directed the largest, and 46 percent of female orchestra managers administered the lowest budget quartile of orchestras while just 5 percent managed the largest.

Differences by Budget Size
Each set of administrators was divided into four quartiles based on the dollar operating budget of their institutions (see table 1-1). Not surprisingly, managers of the largest institutions by and large had spent more years in their fields than administrators of small organizations, which suggests that

Table 1-1

Budget Ranges by Category and Discipline (in thousands of dollars)

Discipline	Lowest quartile	2nd quartile	3rd quartile	Top quartile
Theaters	less than 260	260-500	501-1200	more than 1200
Orchestras	less than 320	320-700	701-1700	more than 1700
Art Museums	less than 500	500-1000	1001-2000	more than 2000
CAAs	less than 50	50-100	101- 300	more than 300

the latter group tends either to move to larger organizations or to leave the field. Managers of wealthy institutions also tended to be slightly older than managers of small organizations, especially in the case of the resident theaters. Directors of the largest art museums were more likely than other directors to have attended private secondary schools and colleges in the northeast, and to have earned Ph.D.s; most striking was the finding that almost 40 percent of art museum directors from the largest museums and more than 25 percent of those from the next largest hold undergraduate or graduate degrees awarded by a specific American university, compared with just 5 percent of those from smaller museums.

Differences by Cohort

Assertions that administrators have changed in recent years can be evaluated by looking at the differences between cohorts—that is, between managers who began their careers in different eras. After dividing each managerial population into three cohorts based on the year in which they took their first full-time jobs in their fields (see table 1-2), we compared their experiences to look at change over time.

For three reasons, however, such cohort data must be interpreted with caution.[3] First, we know that some individuals who entered the field along with the oldest cohorts have now left it, and that some members of our youngest cohorts will soon be gone. But our data cannot tell us whether membership characteristics between cohorts differ because different sets of managers were recruited at different times or because different kinds of managers experience different rates of attrition.

Second, when we compare cohorts we cannot always distinguish *period effects* (effects of the era in which a person entered the field) from *aging effects*. For example, we have seen that, in all four fields, top executives of wealthy institutions were older than top executives of small ones. A visitor

Table 1-2

Cohort Categories for Each Discipline, By First Year of First Job in Field

Discipline	Cohort 1	Cohort 2	Cohort 3
Theaters	Before 1967	1967–1974	After 1974
Orchestras	Before 1964	1964–1973	After 1973
Art Museums	Before 1963	1963–1968	After 1968
CAAs*	Before 1976	1976–1978	After 1978

* First full-time job in the arts.

from outer space might logically attribute this finding to a period effect, concluding that people who went into the arts 20 years ago entered major institutions while those entering arts management today prefer smaller ones. But we are more likely to believe it reflects an aging effect: when managers leave their mark on a field, they are offered jobs at larger and more prestigious institutions that will not hire inexperienced managers. In distinguishing true cohort effects from the effects of differential attrition or aging, then, we must go beyond the data and draw on experience, intuition, and common sense.

Finally, the reader should note that the years that define cohorts differ from discipline to discipline, depending on the distribution of entry years in each managerial group. Thus, a member of the most senior cohort of CAA directors may have had fewer years of experience than a member of the least senior cohort of art museum directors. In general, the brief time span of most CAA directors' careers created a paucity of notable differences among cohorts in that field.

Despite these caveats, some striking findings emerge from the analysis of cohort variation among the four arts administrator populations. Not surprisingly, managers with seniority were more likely to command the largest—and less likely to command the smallest—organizations in each field than were recent entrants. More notably, in each discipline, the percentage of female administrators grew with each successive cohort. For example, 48 percent of orchestra managers entering the field since 1973 were women, over three times as many as those taking their first orchestra job before 1964. Similarly, the percentage of women among senior resident theater managers more than doubled among the "newcomer" cohort. But while these findings are consistent with increased opportunities for women in arts organization management, they are also consistent with greater attrition of women managers over time. That is, the data would look the same whether women were doing better (a cohort effect) or were simply dropping out of these fields as they got older (an attrition effect).

Except in the orchestra field, the educational attainment of top managers appeared to increase over time. While more than 25 percent of senior CAA directors lacked the B.A., under 10 percent of the most recent entrants did. And fewer than half of the most senior theater managers pursued their education beyond the B.A., compared with approximately 60 percent of each subsequent cohort. Finally, 55 percent of the newest art museum directors earned Ph.D.s, over three times the proportion as in the most senior cohort.

Surprisingly, the dramatic increase in formal education among art museum managers has been accompanied by a decline in measures of parental social status. Among those in the most recent cohort, fewer had parents who were professionals or who owned or ran large businesses, and

15

more came from blue-collar and middle-class business families. Moreover, fewer had grandparents born in North America, and even fewer attended private secondary schools. Thus, entry into the art museum field (and, to a lesser extent, into the theater field as well) seems to have become less strongly related to family background and more directly a product of educational accomplishment. (Note that these findings could have resulted from attrition if directors from higher-status backgrounds stayed in the field longer than those from more modest homes, but there is nothing to suggest this was the case.)

Recruitment into Arts Administration

A crucial concept in thinking about careers is that of "entry portal."[4] To develop a career in a field, a person must first enter a career track. The opportunities for entry will determine the kinds of individuals who build careers there. Fields with many entry portals will recruit diverse men and women into top positions, thus accumulating talent from a wide range of sources. Fields with only one entry portal will tend to recruit persons with similar backgrounds, socialization, and values into important jobs, thus insuring that such individuals will probably fit easily into the roles available to them.

Each of our four artistic fields offered multiple entry portals and lacked fixed credential requirements for employment. Before reviewing the different paths leading up to top administrative posts in each field, we should first note that almost half of the art museum directors and orchestra managers began their careers before 1965, whereas over half of the theater managing directors entered theatrical work after 1971, and almost three quarters of the CAA directors entered their field after 1975 (although many had worked in the arts before then). Thus, the orchestra and art museum fields had a larger core of veterans than did the other two.

Resident Theater Administrators
Almost half of all theater managing directors entered theater work directly from formal schooling (usually college). This was more often true of older rather than younger cohorts, however, the latter being almost three times as likely to have apprenticed in other arts or communications fields (e.g., journalism or art-festival management). (Although this suggests that it may have become more difficult to enter theatrical work directly from school, it is also possible that staff entering from school were likely to stay in the field longer than those with other backgrounds, in which case the data would reflect differential attrition.) The third largest group of theater managers (14 percent) first taught in primary or secondary schools before taking a

theater job, and about one in ten theater managers worked in business.

More than one third of all managing directors were hired directly into top administrative positions, and almost half were promoted to such positions while still with their first employers. Almost half entered the field in subordinate administrative posts (e.g., assistant managing director, marketing director, public relations staff). Fewer than 10 percent, however, began their careers as artistic directors or actors, while a similar proportion entered in technical positions such as stage manager or set designer. Those who *did* get their start in artistic or technical work were three times more likely to be men (women tending more to be recruited into top management as interns, administrative assistants, or other management staff), and were less likely to manage the largest quartile of resident theaters.

Orchestra Managers
Orchestra managers were twice as likely as theater managing directors to have entered their field from other artistic or communications fields (primarily media or press, elementary or secondary music teaching, and other performing arts management) or from a business career. Although overall they were less likely than theater managing directors to have entered their field directly from school, the opposite was true for members of the youngest cohort of orchestra managers, a third of whom—in contrast to the youngest cohort of theater managers—entered as soon as they completed their formal education.

Almost half of all orchestra managers began as top managers, with 17 percent more attaining that position with their first employers; over a third entered the field as interns or assistants, as marketing or developing directors, or in other managerial posts. Women were seven times more likely than men to have entered as secretaries or special project staff. Orchestra managers were less likely than theater managing directors to have entered their field in artistic or technical positions (just 11 percent began as musicians or conductors). Finally, managers of the largest two quartiles were almost twice as likely as managers of smaller orchestras to have started in the field as top managers.

Art Museum Directors
Of all the managers surveyed, art museum directors had the most regular entry patterns, entering museum work through schooling (43 percent) or after teaching art history in college (25 percent). Almost half of those recruited from school went into curatorial positions (the starting point for almost one third of the directors), whereas more than half of those recruited from professorial positions were first hired as directors. Overall, almost one quarter started off as directors, and almost one fifth began in such other

administrative positions as assistant or associate director. Those recruited from sources other than school or university teaching entered into a mix of directorships, curatorial positions, educational jobs, and other administrative posts.

Recruitment backgrounds of male and female art museum directors were very similar, as they were for directors across the four budget quartiles, except that directors of the smallest museums were far less likely to have gone directly from school into the art museum field.

Cohort data revealed that patterns of recruitment to the art museum field changed over time. Recent entrants were less likely to have entered museum work directly from school than were members of other cohorts, the proportion declining over time from 61 percent of the most senior cohort to 21 percent of the most junior. On the other hand, newcomers were more likely to have been hired straight off as directors and were less likely to have first served as curators.

These findings must be interpreted with caution. We would expect the observed proportion of recent cohort members moving directly into directorial jobs to be higher than the "true" percentage (i.e., the percentage of all persons entering the field during the most recent period who will ever be directors), because individuals who entered recently as curators have had less time to move into the management ranks. Similarly, the apparent change in recruitment patterns might be explained if persons entering museum work directly from school take longer to become directors than persons with professorial experience.

Still, two factors suggest that these findings were not entirely artifactual. First, the trends toward both greater previous work experience and a greater likelihood of entering the field as a director appeared between the first and second cohorts as well as between the second and third. Second, more directors in the current cohort have Ph.D.s and teaching experience at the university level (53 percent compared with 31 percent in earlier cohorts). Thus, it seems likely that, along with the trend toward higher educational attainments among museum directors, we are also witnessing a trend toward more university teaching experience and shorter periods in the field before appointment to a first directorship.

CAA Directors
Compared with those in other fields, preentry positions and entry portals were most diverse among the CAA directors, with no evidence of routine recruitment patterns. About one third of the CAA directors entered artistic or arts administrative work directly from school; the only other source of recruitment accounting for more than 10 percent of the respondents was nonprofit management.

18

The first arts jobs of almost half the directors were in the community arts fields, while just over 40 percent entered the field from other arts or media organizations. The rest were scattered among a wide range of pursuits. Only 10 percent of the CAA directors, far fewer than the top managers in other fields, went directly from school into their current field. Yet for over 80 percent, their first job in the community arts was a directorship, and nearly all became directors while still with their first community arts employers.

Male directors were more likely than their female counterparts to have entered the field directly after graduation and were almost twice as likely to have been recruited from theater management. Women, on the other hand, were about twice as likely to have worked in the press or media or to have taught, and were about five times as likely to have held secretarial or clerical jobs or to have served as volunteers.

Finally, managerial backgrounds differed neither by budget category nor by cohort.

Thus, the artistic fields studied here tend to reflect the benefits of diverse backgrounds rather than of consistent preparation and socialization. Each field attracted many eventual managers directly from school and drew few from business management. There is little evidence that arts managers are either failed artists or, as a group, artistically naive. Although most administrators went into management at an early stage of their careers, some had brief artistic experience. Furthermore, substantial proportions in each field had earned undergraduate degrees in the art forms they managed, and those who had not were more likely to hold college degrees in the humanities than in arts administration or general management.

Managerial Careers

In some fields (e.g., medicine, government service, university teaching) recruits are aware of a number of conventional, sometimes mandatory, steps that can lead to positions of power and prestige. In other fields, the paths of achievement are less apparent. The career paths taken by arts administrators once in their fields are as varied as those taken prior to recruitment.

In each of the four fields, approximately 10 percent of the top executives had worked for more than four employers during their careers (not counting unrelated positions prior to entry); between one half and two thirds had worked for only one or two. Art museum and theater managing directors tended to have the longest spells of employment: 30 percent of the former and more than one fifth of the latter had been with their current employers for over 10 years. Orchestra managers were comparable to theater ad-

ministrators in their tenure, while just 5 percent of CAA directors had worked for more than 10 years for their current employers.

Most respondents were hired into their current administrative positions from outside: only about one quarter of the theater, orchestra, and art museum executives, and just 14 percent of the CAA directors, had been promoted from within. Careers culminated in top managerial positions most quickly among CAA directors, 82 percent of whom served no prior apprenticeship in the field (although they tended to have longer work experience outside the field), whereas almost half of the orchestra managers waited longer than 5 years before reaching their positions, and almost one quarter waited for more than 10 years.

Theater managing directors were promoted youngest, with 43 percent becoming executives before age 30, and all but 10 percent in managerial posts before turning 40. By contrast, orchestra managers and museum directors were far more likely to become executives after age 40.

Few managers in any field had held more than two executive positions, suggesting that job-hopping is uncommon among those who have attained top managerships. However, prior work experience among managers before they attained their positions varied among and even within fields.

In theaters, for example, substantial minorities had worked as actors, artistic directors, "techies," commercial theater or summer stock administrators, teachers or professors, or public arts agency employees. But none of these categories included even one third of all managing directors surveyed. Similarly, relatively few managing directors had direct experience in theater marketing, development, and public relations, nor had many managed other performing arts organizations or worked in non-arts businesses.

Female managing directors had much more experience than their male counterparts working in theater public relations, marketing or audience development, and fund-raising or development; further, they were twice as likely to have taught in primary or secondary school or to have worked in commercial theater. By contrast, men were three times more likely to have worked in a public arts agency.

Experience in theater public relations, marketing, or development was far more prevalent among managing directors of the smallest quartile organizations, who were also much more likely than managers of larger ones to have worked as actors, directors, or technicians. On the other hand, managers in the largest budget quartile were notably more likely than their peers to have worked in public arts agencies and summer stock.

Analysis of intercohort variation suggests that managerial work experience changed strikingly over time. The percentage of managing directors with experience in public relations, development, or marketing—three

key management functions involving the theater's external environment—increased steadily with each cohort (from 7 percent among the most senior directors to 33 percent among the most junior). At the same time, the percentage of those involved in artistic or production work declined modestly but just as steadily, as did the percentage of those with backgrounds in commercial theater, summer stock, and college teaching. It is possible, however, that the latter declines represent age effects, since managing directors may gain experience in these fields after they have already become involved with the resident stage (whereas they are unlikely to become actors or development directors after they have been managing directors).

The same diversity in experience is apparent among orchestra managers. Although more than one fifth (mostly males) had worked as musicians, almost the same number had experience in non-arts businesses. Still others had worked as elementary or secondary school teachers, for artists' agencies, or in other performing-arts management positions. Managers of the largest budget quartile were only one third as likely as others to have taught in elementary or secondary schools, and it was also rarer for them to have worked as orchestra musicians. By contrast, the percentage of managers having worked in opera, dance, or theater management—as well as of those with experience in orchestra development, public relations, or marketing—ascended with size, in both cases from 4 percent among managers of the smallest orchestras to 22 percent among managers of the largest.

As with resident theater managers but to a less-marked degree, the trend among orchestra managers, from the most senior cohort to the most junior, appeared to lead away from prior artistic experience and toward business and managerial experience. While the percentage of managers who had been either orchestra musicians or music teachers has been gradually declining, the percentage of those reporting experience in non-arts businesses, orchestra public relations, development, or marketing has been on the increase.

Compared with theater and orchestra careers, those of art museum directors were relatively routine; yet even here, no kind of premanagerial work experience was shared by even half the respondents. The most common prior experience was curatorship, reported by nearly half the directors, while almost as many had taught art at the college or university level. Smaller groups had worked as associate or assistant directors, in art museum education departments, or as elementary or secondary school teachers. Surprisingly, fully 20 percent (mostly male) reported being employed at some point during their work careers in a business unrelated to the arts.

The relatively few women art museum directors were only half as likely as men to have worked in non-arts businesses, and they were more likely to have worked for nonprofit organizations outside the arts, in clerical museum positions, or as elementary or high school teachers. Among directors

of the smallest museums, prior teaching experience was quite prevalent; these persons were far more likely than directors of larger museums to have served as professors before entering museum work, to have taught in elementary or secondary schools, or to have worked as museum educators.

University-level teaching was significantly more common in the prior careers of the most junior cohort as compared with those of the most senior (48 percent to 6 percent, respectively). Also notable was the decline in the percentage of directors with curatorial experience (from 58 to 35 percent), suggesting that a Ph.D. may be replacing curatorial service as preparation for art museum directorships. Finally, in contrast with the findings for the performing arts, the percentage of directors with business experience outside the arts appears to have declined.

The experiences of CAA directors were the most diverse of all. Because most CAA directors took on directorships upon entry into the field, no internal position prepared them for their work. Nor, as we have seen, were there regular recruitment channels. Prior experience included teaching (in primary and secondary schools as well as in schools for the arts), university arts management, arts service organization and secretarial/clerical employment, theater or orchestra management, performing, employment in a commercial venture, experience as a visual artist, work in an arts center, or work in a non-arts business. Finally, no major differences based on gender, budget category, or cohort were visible.

Conclusions

Although the careers described in this chapter were relatively unroutinized and idiosyncratic, some general conclusions can be drawn. To begin with, the managers of larger arts organizations were, as a group, men and women from families of relatively high social status. Women were a significant presence in every field but the art museums, but they were always more likely than men to be directing smaller, less prestigious institutions.

Moreover, educational levels of these managers were high—more than half have pursued their formal educations past college—and seemed to be rising, dramatically among art museum directors and more gradually among others. If formal educational credentials and prior work experience are a guide, the managers' arts backgrounds were rather strong while their management experience was meager. Nonetheless, there were numerous exceptions to these assertions, along with some evidence that management training and experience were becoming more common and artistic experience somewhat rarer among performing arts managers, especially those in resident theaters.

Cohort analysis suggests that each field has been changing in distinc-

tive ways, with the exception of CAAs, the directors of which were usually such recent entrants into the field that few conclusions could be drawn about change.

Art museums have undergone professionalization, in the sense that their directors—especially those of the largest institutions—have increasingly impressive educational credentials and increasingly commonplace social backgrounds. University teaching experience is more common in the recent cohort than among previous entrants to the field, while curatorship seems to have undergone a concomitant decline as a stepping-stone to the directorship.

Among resident theaters (and orchestras, to a lesser extent), artistic expertise has become somewhat less common and managerial training more widespread.

Data from this study reveal that careers—i.e., ordered sequences of jobs leading from conventional entry portals to predictable destinations— did not exist in these fields. (Indeed, other research has demonstrated that orderly careers are, in general, far less common than most people believe.)[5] Arts managers were recruited from many sources and brought with them a panoply of experiences, and many entrants in all the fields moved directly into top executive positions. Further, mobility within organizations is limited by size: relatively few arts institutions have enough levels of management to promote routinely all competent personnel. And movement among organizations at the executive level appears to be less common than widespread perceptions of job-hopping would suggest.

The disorderly nature of managerial careers in these artistic fields may provide opportunities for organizations to hire talented individuals from unusual backgrounds and for individuals willing to take risks to build successful careers. But many people find it stressful to work in environments in which promotion opportunities are few and career strategies obscure and poorly understood. Such individuals, if they face career stagnation or uncertainty, may choose to leave arts administration for other pursuits.

Notes

1. See, e.g., Judith Kurz, "Meeting the Challenge: Management Fellows Train for the Eighties and Beyond," *Symphony* (August/September 1982): 39-44; Theatre Communications Group, "Institutionalization: Bane or Blessing to the Art of Theatre?" in *Report of the 1980 National Conference* (New York: Theatre Communications Group, 1980), 51-52; Alan Shestack, "The Director: Scholar and Businessman, Educator and Lobbyist," *Museum News* 57 (November/December 1978): 27-31 ff.; and Ralph Burgard, "The Elaborate Minuet and Other Hard Lessons," *American Arts* (March 1980): 18-19.

2. For a notable exception, see Susan Stitt and Linda Stein, *The Museum Labor Market: A Survey of American Historical Agency Placement Opportunities* (Sturbridge, Mass.: Old Sturbridge Village, 1976).

3. For a useful introduction, see Norman Ryder, ''The Cohort as a Concept in the Study of Social Change,'' *American Sociological Review* 30, 6 (1965): 843-861.

4. See Seymour Spilerman, ''Careers, Labor Market Structure, and Socioeconomic Achievement,'' *American Journal of Sociology* 83, 3 (1977): 551-593.

5. Spilerman, ''Careers, Labor Market Structure, and Socioeconomic Achievement.''

2

Rewards and Expectations

An artistic discipline not only must induce capable managers to pursue careers within the field and provide them with the needed experience and knowledge to ensure that they will succeed. It must also compensate and reward them sufficiently to ensure that they will remain.

While many of the rewards arts administrators receive from their jobs are predictably economic ones, including salary and control over resources (as measured by organizational budget), there is also a range of noneconomic satisfactions. Such factors greatly influence administrators' expectations as to whether they will continue to work in the arts.

Salary and Resources

Salary was related to the employing organization's operating budget in every field, very highly in the performing arts and more modestly in art museums and CAAs. The lower correlation of salary with budget size among art museums was partly an artifact of the restricted upper category of the salary scale on the survey (respondents were asked to check the range in which their salary fell). It may also have resulted from the inclusion of university art museum directors, some of whose salaries were tied to university teaching scales. Similarly, the salaries of municipal CAA directors may have been constrained by municipal salary scales.

Generally speaking, however, administrators of larger organizations earned more generous salaries. Over half of the orchestra managers and 86 percent of the art museum directors earned more than $27,500, com-

pared with fewer than one third of the theater managing directors and just 21 percent of the CAA directors (see table 2-1). At the same time, art museum and orchestra administrators commanded more resources (mean budgets of $1.9 and $1.8 million, respectively) than did theater managing and CAA directors (mean budgets of $954,000 and $354,000, respectively). (In all cases, means are inflated by the presence of a few atypical organizations with exceptionally high budgets.) Similarly, male managers, who administered larger organizations in every field, were better paid than women managers. Among the resident theater respondents, for example, 45 percent of the men but just 3 percent of the women earned more than $27,500 annually; and distributions were analogous, although less extreme, in other fields. Finally, managers in more senior cohorts directed larger organizations and so earned more than did more recent entrants in every field.

In addition, theater managing directors with degrees in management and *without* experience in theater marketing, development, or public relations departments; art museum directors with Ph.D.s in art history and any degree from one specific major American university; and CAA directors with arts degrees and prior arts experience were also all better paid than were their counterparts without these attributes.

Note that these observations describe associations, not causal relationships, and they tell us nothing about how these associations might be altered. Take, for example, the finding that women earned less money than men. If this was because women managers were less well educated than men, it could be changed by training female arts administrators. If it was because women were less experienced, the difference would be expected to moderate with time, at least if male and female recruits were equally likely to remain in their fields. If the difference existed because women worked for

Table 2-1

Salary by Field
(percent)

	Theaters	Orchestras	Art Museums	CAAs
$0-$10,000	12.74	2.78	1.63	4.58
$10,001-$15,000	18.63	9.26	0.81	18.32
$15,001-$20,000	14.71	10.19	2.44	29.77
$20,001-$27,500	22.55	25.93	8.94	25.95
$27,501-$35,000	10.78	19.44	14.63	12.98
$35,001-$50,000	13.73	14.82	45.53	7.63
over $50,000	6.87	17.59	26.02	0.76
(Respondents)	(102)	(108)	(123)	(131)

smaller employers than did men, the problem would rest both in the nature of women's careers and in large organizations' hiring patterns. If similar organizations paid women less than they would have paid men with the same talents and credentials, women would have recourse to legal remedies.

To distinguish the causes of this observed variation, we used a statistical technique known as multiple regression analysis. This technique allows one to investigate the effects of each independent variable on an outcome while simultaneously controlling for each one. For example, a multiple regression analysis of the impact of rainfall, sunshine, and fertilizer on the height of tomato plants would permit us to estimate the effect of each factor alone, irrespective of the others. Note that the term *effect* refers to statistical effect rather than to causality. Although such findings are consistent with the existence of real effects, they do not in themselves *prove* that those effects exist. For the sake of brevity, the phrases "other things equal," "net effects," and "controlling for other factors" will not be included in every sentence in the report of regression results. The reader should note, however, that unless otherwise indicated, descriptions of results all refer to net associations—that is, controlling for the influences of other measured factors.

Let us first consider predictors of budget size. The budget a manager commands is an important source of reward in its own right and is related as well to salary, especially in the performing arts. In all but the art museum field, and especially among resident theaters, being a woman was negatively associated with budget size, even after controlling for family background, education, and career experience.

The effects of family background were small in all fields, although parents' educational attainment exerted a modest positive effect on budget size for orchestra managers and a modest but surprising negative effect on budgets commanded by art museum directors. Managers in all fields who attended private secondary schools (a measure of family social status), as well as orchestra managers who attended more selective colleges, administered larger budgets, other things equal. By contrast, years of education had a surprisingly negative impact on the budgets commanded by CAA directors, even after controlling for years in the field. Notably, the major influence on the budget size of art museum directors was attendance at a specific major American university.

Aspects of age and seniority had strong positive net effects on budget size in every field except the art museums. Years worked before entering the field substantially influenced budgets administered by CAA directors, as did years of work experience in the field, which was also a powerful net predictor of organization budget for orchestra and theater administrators.

In our regression analyses of managerial salaries, budget size was by

far the most important predictor of salary among the theater and orchestra managers; additionally, it exerted an important influence on the salaries of CAA directors and a more modest, but still notable, net effect on those of art museum directors.

Salaries were also influenced by experience. Years of work experience was a very powerful predictor of salary in the performing arts and, to a slightly lesser degree, among the CAA directors, while a closely related measure, years of experience in the arts, was an important predictor of art museum directors' salaries. Surprisingly, holding experience constant, managers of orchestras who reported long tenures with their current employers earned substantially less than managers with briefer tenures. This was not the case, however, in other fields.

The impact of educational experience on salary varied in importance from the art museum field, where it was crucial, to the orchestra field, where it was negligible. The salary of art museum directors was notably influenced by attendance at a specific American university, although not as much as it was by years of educational attainment. In the museum field, then, the income determination process appeared to have components of both meritocracy and old school ties.

Among CAA directors, educational attainment was as strong a predictor of salary as was budget size and years of experience. Thus, its effects for this group were mixed, given that its direct positive impact on salary was countered by an indirect negative impact through its negative influence on operating budget.

Finally, private secondary school attendance bore a moderately strong relationship to the salaries of theater managing directors. Graduates of private schools were doubly advantaged here: they were more likely to administer large theaters (and thus to benefit from the strong effect of budget size on earnings), and, holding budget constant, they still earned more money than similar men and women who attended public schools.

Unless private school attendance is seen as a measure of social status, family background had no direct effect on the incomes of theater managing directors. Parental education, on the other hand, was negatively associated with income among the orchestra managers, an impact that was balanced by its positive influence on organizational size. And after controlling for educational experiences, parental social class had a similarly negative impact on income in the art museum field. These negative associations were puzzling; perhaps individuals from humble backgrounds who attained advanced degrees, attended major universities, and became art museum directors or orchestra managers had unmeasured qualities that enabled them not only to obtain what traditionally had been elite jobs but also to earn higher salaries once they got them. Finally, CAA directors from top business or

professional families earned higher salaries than comparable directors from more modest backgrounds.

One of the most striking similarities among the four fields was the influence of gender on managerial salaries. Although controlling for family background, educational and career experience, and organizational budget size reduced the negative impact of being female by one third for art museum directors, one half for CAA chiefs, and almost two thirds for theater and orchestra managing directors, the effects that remained were notable. Because women also tended, other things equal, to direct smaller organizations, they were doubly disadvantaged. Unless male and female managers in these fields differed on some unmeasured traits that were uncorrelated with the other variables (a possibility that seems unlikely), it is difficult to escape the conclusion that women managers in these fields earned less money than did comparable men.

Intrinsic Rewards: Work Satisfaction

If salary and command over resources were all that motivated people, we would expect resident theaters and local arts agencies to have a harder time attracting and retaining capable managers than orchestras and art museums. But if managers compare their organizations and salaries chiefly to those of peers in their fields rather than to those in the arts more generally, these factors may be offset by other satisfactions intrinsic to the work of managing the arts.

To pursue this notion, we asked respondents to rate the satisfaction they derived from various aspects of their work, including their salaries. These ratings were made on a five-point scale, on which "5" represented "a source of great satisfaction," "1" represented "a source of great dissatisfaction," and "3" represented those factors that aroused apathy or ambivalence. For each set of managers and each satisfaction they received, table 2-2 indicates the mean, the rank of this mean (in parentheses) among all factors for the group, the percentage indicating satisfaction ("4" or "5"), the percentage indicating *dis*satisfaction ("1" or "2"), and the number of respondents. Finally, the satisfactions themselves are ranked according to average mean across all four fields, although this does not reflect the order in which they were presented to respondents.

Overall, the four groups of administrators found more sources of satisfaction than of dissatisfaction on the list. If we consider a mean of 3.51 or higher to indicate satisfaction and 2.49 or lower to indicate dissatisfaction, none of the factors was, on balance, a source of real dissatisfaction, and only contacts with donors (for CAA and theater managing directors), salary (for all but art museum directors), and contact with government agen-

Table 2-2 Job Satisfactions, by Field (percent)

Factors	Theaters	Orchestras	Art Museums	CAAs
Contacts with works of art				
Mean (rank)	4.29 (1)	4.38 (1)	4.46 (1)	3.92 (6)
Satisfied	80.00	85.05	83.20	60.00
Dissatisfied	4.00	0.00	7.20	7.69
(Respondents)	(100)	(107)	(125)	(130)
Autonomy and authority				
Mean (rank)	4.14 (4)	4.14 (4)	4.29 (2)	4.27 (2)
Satisfied	79.21	85.18	84.80	81.06
Dissatisfied	8.91	5.56	6.40	6.06
(Respondents)	(101)	(108)	(125)	(132)
Relations with colleagues at other institutions				
Mean (rank)	4.07 (5)	4.22 (2)	4.16 (3)	4.16 (3)
Satisfied	75.25	80.37	82.93	79.54
Dissatisfied	4.95	0.00	2.44	4.55
(Respondents)	(101)	(107)	(123)	(132)
Role in community				
Mean (rank)	3.88 (7)	4.17 (3)	4.09 (4)	4.38 (1)
Satisfied	78.69	81.31	78.25	84.09
Dissatisfied	7.07	2.80	2.42	4.55
(Respondents)	(99)	(107)	(124)	(132)
Relations with subordinates				
Mean (rank)	4.15 (2)	4.08 (6)	4.08 (5)	4.14 (4)
Satisfied	84.00	72.64	78.22	81.53
Dissatisfied	6.00	2.83	5.65	7.69
(Respondents)	(100)	(106)	(124)	(130)
Contacts with artists				
Mean (rank)	4.15 (3)	4.12 (5)	3.80 (9)	3.98 (5)
Satisfied	77.23	77.78	59.66	69.47
Dissatisfied	2.97	0.93	8.40	7.63
(Respondents)	(101)	(108)	(119)	(131)
Potential for career growth				
Mean (rank)	3.96 (6)	4.00 (7)	3.85 (6)	3.58 (8)
Satisfied	68.63	74.04	66.67	57.58
Dissatisfied	7.84	5.77	7.69	18.18
(Respondents)	(102)	(104)	(117)	(132)
Contacts with board members				
Mean (rank)	3.68 (8)	3.85 (8)	3.81 (8)	3.82 (7)
Satisfied	59.00	68.52	66.39	67.69
Dissatisfied	14.00	7.41	9.24	10.77
(Respondents)	(100)	(108)	(119)	(130)
Contacts with private donors				
Mean (rank)	3.09 (10)	3.55 (9)	3.85 (7)	3.47 (9)
Satisfied	32.00	49.53	64.23	46.09
Dissatisfied	29.00	7.48	4.88	12.50
(Respondents)	(100)	(107)	(123)	(128)
Salary				
Mean (rank)	3.00 (11)	3.46 (10)	3.62 (10)	3.20 (10)
Satisfied	31.37	50.93	56.20	37.12
Dissatisfied	28.43	11.11	7.44	19.70
(Respondents)	(102)	(108)	(121)	(132)
Contacts with govt. agencies				
Mean (rank)	3.16 (9)	3.11 (11)	3.08 (11)	3.20 (10)
Satisfied	36.63	34.26	28.10	40.15
Dissatisfied	19.80	28.70	26.45	24.24
(Respondents)	(101)	(108)	(121)	(132)

NOTE: Factors are ranked from those yielding the greatest satisfaction to those yielding the least satisfaction according to the average mean across all four fields.

cies (for all) were not cited as sources of satisfaction. Administrators in all fields reported much satisfaction in their contact with works of art, their autonomy and authority, their relationships with colleagues, and their relationships with subordinates; they reported relatively less satisfaction with their salaries and with contacts with trustees, donors, and especially government agencies. And although most felt relatively positive about opportunities for career development, none included this factor among the top half of all satisfactions. Thus, the satisfactions that keep managers in their fields and the dissatisfactions that make their work less rewarding seem similar for all disciplines.

A few differences were nevertheless apparent. Not surprisingly, the better-paid orchestra and art museum administrators were more likely to be satisfied with their salaries than were their counterparts in resident theaters and CAAs. Further, managers in the performing arts found more satisfaction in contacts with artists than those in museums and CAAs, probably because they had more regular contact with them; by the same token, CAA directors were less likely to report satisfaction in contacts with works of art, probably because they had less contact.

One might consider troublesome those job attributes noted as sources of dissatisfaction by 10 percent or more of the respondents in a field. While all but art museum directors fell into this range in citing salary as a source of dissatisfaction, more than one quarter of the theater managing directors responded to that effect, and almost 30 percent of them rated contacts with donors negatively. Contacts with government agencies and with board members were also considered irritants in the resident theater field.

A similar pattern emerged from the responses of the CAA directors, almost one quarter of whom voiced dissatisfaction with contacts with government agencies.[1] And although some also viewed contacts with board members and with donors as irritants, perhaps more significant were the relatively high percentages dissatisfied with both their salaries and their opportunities for career growth. Possibly the absence of conventional career sequences in the community arts was, as suggested in chapter 1, a source of anxiety to administrators in this field.

By comparison with the theater and CAA administrators, orchestra and art museum directors appeared well satisfied. Their only frequent expressions of dissatisfaction referred to their contacts with government agencies.

Variation Between Men and Women
Male and female theater managing directors responded similarly; however, men were much more satisfied with their (higher) salaries and slightly more satisfied with their community roles, while women were slightly more satisfied with their opportunities for career development and more dissatisfied

31

with their autonomy and authority. On the other hand, male and female orchestra managers diverged in their responses: men reported more satisfaction from their salaries, their autonomy and authority, their community roles, and their contacts with works of art; women expressed more satisfaction with their relationships with colleagues, their contacts with board members, and their opportunities for career development.

Male and female art museum directors also had different responses to these questions, although the small number of women in this field makes generalization hazardous. Nevertheless, men were more likely to express satisfaction with their salaries, while women reported greater satisfaction with their contacts with artists, board members, donors, and government agencies, and with their roles in the community. Women were less likely than men to express dissatisfaction with their opportunities for career development.

Finally, women CAA directors reported more satisfaction than their male colleagues in each area in which differences emerged—namely, their relations with colleagues in other institutions, their contacts with board members, their community roles, and their contacts with works of art. Similarly, they were less likely to find dissatisfaction in their contacts with government agencies.

Variation by Cohort
Interpretation of cohort differences in attitudes is treacherous for several reasons. For one thing, members of the most senior cohort in each field are survivors; less-satisfied managers who entered their fields along with them may have dropped out before reaching their level of seniority. Second, some attitudes change with age and experience. If we were to survey individuals in the junior cohort in 15 years, those who remained might provide responses more similar to those of today's most experienced cohort. Differences among cohorts, then, may result from the recruitment of individuals with stable attitudes into the field at different times; from differences in age and experience that will moderate with time; or from the winnowing out of less-satisfied members of more senior cohorts who have left the field.

In general, newer entrants to all four fields expressed less satisfaction than did the more senior cohorts. Where this lack of satisfaction was expressed with some frequency, we may expect that a substantial minority of this younger cohort will not remain in the field until retirement. Where contacts outside the employing organization were found to be more satisfying than those within, as seemed to be the case (relatively speaking) for the most recent cohort of art museum directors and the middle cohort of CAA directors, some administrators may begin to focus more on activities

in the profession than on local organizational dilemmas. Although satisfaction with career development opportunities was never so low among newcomers as to lead us to predict a mass exodus, the combination of satisfactions and dissatisfactions in each field seemed likely to cause a minority of younger managers eventually to leave.

Variation by Organization Size

Organization budget size was positively associated with the expressed satisfaction among theater managing directors, but this was not so for other respondents. In the art museum field, directors of small institutions tended to report the highest degree of satisfaction overall. Among orchestra managers and CAA directors, the relationship between size and satisfaction varied, depending upon the specific aspect of the job. In all fields but the resident stage, managers of the largest institutions derived the least satisfaction from contacts with artists. And in all fields but theater, but especially in orchestras and the community arts, managers of the largest organizations tended to be less satisfied than others with their opportunities for career advancement. This last finding suggests that some managers who had been very successful may have become frustrated once they reached the top of their professions. These fields may thus find it difficult to retain able administrators who attain top positions early in their careers.

Taken together, the results suggest that, outside of the theater at least, intrinsic rewards may have compensated for income among managers in the smaller organizations, while relatively high salaries may have induced other individuals to manage the largest organizations, even though they found the intrinsic qualities of these jobs to be less rewarding than did their smaller budget peers.

Career Expectations

If arts organizations are to be well administered, it is not enough for them to recruit talented individuals into administrative positions. The field as a whole must retain these individuals as they become more experienced and develop greater skills.

In our survey we queried managers about their expectations regarding future career movement. Although people do not always do what they expect to do (unforeseen opportunities arise, attitudes change, plans undergo sudden shifts), such questions provide a more direct measure than do satisfaction reports of the directions in which administrators thought they were heading.

Each set of managers was asked to indicate their likelihood of taking each of several kinds of jobs in the future. They did this by circling one

33

number on a four-point scale in which "4" equaled "very likely" and "1" equaled "very unlikely."[2] The job alternatives varied for administrators in each discipline, based on the nature of their work and experience. Table 2-3 shows the mean response in each field to each alternative posed (not all alternatives were applicable to all fields), the percentage of administrators who considered the alternative either "very likely" or "somewhat likely," and the number of respondents. In analyzing the resultant data, we paid particular attention to respondents' evaluations of the likelihood that they would, first, take a job in a larger or more prestigious organization in their field and, second, move to a position unrelated to the arts. The former expectation was most consistent with both a commitment to one's discipline and an optimistic view of one's opportunities in it. The latter was most directly related to our concern about retention of managers in the arts.

Managers in all fields were remarkably similar in their future expectations. Just over half in each field expected to move to a similar organization, and approximately two thirds expected to command a larger or more prestigious organization in their field.

There was more variation, however, in the percentages of managers who expected to leave the arts: half of the CAA directors considered this to be likely, compared with approximately one third of the administrators of theaters, orchestras, and art museums. There are several reasons why the local arts agencies seemed more at risk than other fields of losing many of their managers. First, CAA directors were newer to their fields than were other arts administrators, and so they had had less time to build commitment to the field. Second, careers in the community arts were even less structured, and thus more uncertain, than those in the other fields considered here. Third, CAA directors commanded smaller organizations than other managers and earned relatively low salaries, as well. In the long run, the development of a larger cadre of experienced managers and the routinization of careers should moderate the difference between local arts agencies and other kinds of arts organizations. In the short run, however, loss of administrative talent promises to be a vexing problem for local arts agencies.

Managers can leave administrative positions in their fields without leaving the arts altogether. Respondents were asked to estimate the probabilities that they would administer other kinds of arts organizations, take jobs either with public agencies concerned with the arts or with arts service organizations, assume positions in the commercial media, or work in the commercial stage. Responses reflected the vulnerability of CAAs, whose directors were considerably more likely than others to consider it probable that they would pursue such alternatives. These jobs were much less attractive to art museum directors and orchestra managers, whereas the responses of managing directors of resident theaters formed an intermediate pattern.

Table 2-3

Likelihood of Future Job Alternatives, by Field (percent)

Alternatives	Theaters	Orchestras	Art Museums	CAAs
Same/similar position as now at similar organization				
Mean	2.64	2.49	2.68	2.53
Likely	58.00	52.78	62.09	55.38
(Respondents)	(100)	(108)	(124)	(130)
Same position as now at larger or more prestigious organization in same field				
Mean	2.81	2.84	2.85	2.73
Likely	67.00	67.59	65.04	64.82
(Respondents)	(100)	(108)	(123)	(131)
Artistic position[a]				
Mean	2.27	1.25	1.75	1.45
Likely	29.41	6.60	22.76	13.85
(Respondents)	(102)	(106)	(123)	(130)
Director or staff of a public agency concerned with art form[b]				
Mean	2.23	2.02	1.79	2.73
Likely	40.20	31.48	22.76	68.18
(Respondents)	(102)	(108)	(123)	(132)
Director or staff of an arts service organization				
Mean	2.21		1.54	
Likely	39.22	NA	16.13	NA
(Respondents)	(102)		(124)	
Art administration in another field[c]				
Mean	1.94		1.48	2.44
Likely	22.55	NA	12.10	50.00
(Respondents)	(102)		(124)	(132)
Administrator or staff in a commercial media concern[d]				
Mean	2.19	1.90	1.41	2.06
Likely	32.00	29.91	9.68	33.59
(Respondents)	(100)	(107)	(124)	(131)
Producer or administrator in commercial stage				
Mean	2.57			
Likely	52.94	NA	NA	NA
(Respondents)	(102)			
Director of a social service agency				
Mean				1.61
Likely	NA	NA	NA	16.79
(Respondents)				(131)
Job unrelated to art form[e]				
Mean	2.23	1.97	1.86	2.47
Likely	33.33	35.18	29.27	50.38
(Respondents)	(102)	(108)	(123)	(131)

NOTES: NA = not asked/not applicable.

[a] For theaters, 'artistic director of a resident theater'; for orchestra, 'professional musician'; for museums, 'curator'; for CAAs, 'visual or performing artist.'

[b] For theaters and orchestras, 'concerned with the performing arts'; for museums, 'concerned with museums'; for CAAs, 'concerned with the arts (other than a CAA).'

[c] For theaters, 'orchestra, opera, or dance company'; for museums, 'a museum that is not an art museum'; for CAAs 'a performing arts organization or a museum.'

[d] For art museums, 'director of a commercial gallery'; for other fields, as it reads.

[e] For theaters and orchestras, 'unrelated to the performing arts'; for museums, 'unrelated to museums or the visual arts'; for CAAs, 'unrelated to the arts.'

Variation Between Men and Women

Women in all fields were somewhat less likely to anticipate moving to larger or more prestigious organizations than were their male colleagues. For example, among theater managing directors, three times as many men as women (39 percent versus 13 percent) expected such a career move. Moreover, 52 percent of the women—more than twice as many as the men—expected to take jobs outside of the performing arts. Women theater managing directors were also much more likely to anticipate working in public agencies concerned with the performing arts, arts service organizations, and the commercial media. These findings suggest that the resident stage may lose many women participants through attrition.

In the other fields, however, women appeared no more likely to leave than men; in fact, the relatively few women art museum directors were 50 percent more likely than their male colleagues to report it "very unlikely" that they would ever work outside of museums or the visual arts. And among CAA directors, proportionately twice as many men as women anticipated moving to an arts administrative position outside the community arts.

We should recall here that the more recent cohorts of managers in all fields contain more women than do more senior cohorts. If expectations are good guides to behavior, these gains by women should hold up in orchestras, art museums, and local arts agencies; they may be severely eroded, however, by attrition of female managing directors in the resident stage.

Variation by Cohort

Members of the most junior cohorts in all fields had greater expectations of managing larger or more prestigious organizations in their fields. The middle cohorts were almost as optimistic among the orchestras and art museums but less so among the theaters and CAAs. The lower expectations of more experienced administrators in the latter fields may have reflected disillusionment, but they may also have represented a realistic reaction to two facts: first, the more senior managers had less time left in which to make any moves and, second, because they probably already commanded larger and more prestigious institutions than their more junior peers, there may have been little room left for improvement.

Cohorts also varied in their propensity to leave arts administration. The commitment of art museum directors appeared to build with time: the longer they had served in art museums, the less likely they were to contemplate working outside museums or the visual arts. By contrast, commitment in the other fields actually seemed to decline with experience. In both the orchestra and community arts fields, members of the most junior cohorts were least likely to anticipate leaving the field, while administrators in the middle cohort were most likely to do so.

If arts management and museum administration were becoming professions that span disciplines, we would expect that the newest recruits to theater and CAA administration would have been more likely than the more senior managers to anticipate taking jobs in other fields of arts management; and that the more recent entrants to the art museum field would have been more likely to see themselves directing museums other than art museums. The data, however, provided meager support for this view. It is true that, among the art museum directors, between 15 and 20 percent of the youngest cohort expected to direct a non-art museum, while not a single member of the most senior cohort did. But at the same time, the newest recruits to theater management were less likely than their more senior colleagues to anticipate managing other kinds of performing arts organizations (and fewer than one third of any cohort reported such expectations). Further, although over half the CAA directors expected to move into other kinds of arts management, no trend toward this view was discernible among cohorts. Thus, at this point, different kinds of museums and, to a lesser extent, different kinds of performing arts disciplines appear to constitute separate labor markets.

Variation by Budget Size and Career Experience

Despite substantial variation in managers' expectations among budget quartiles within each field, much of that variation was relatively unpatterned. Directors of the smallest theaters and CAAs were, however, more likely to anticipate working as artists than were administrators of larger organizations.

Where opportunities are blocked for men and women who attain top positions in their fields early in their careers, the discipline may lose the services of its top executives. Indeed, almost half the managers of the largest orchestras reported that they were likely to seek jobs outside the performing arts; and more than half the directors of the two largest quartiles of CAAs (compared with 42 percent of the directors of smaller agencies) expected to leave arts work altogether. These managers were least apt of all respondents to consider it likely that they would administer organizations similar to their own. By contrast, managing directors of the largest theaters were least likely to anticipate leaving their field.

Surprisingly, administrators with management degrees are not more likely to look outside the arts to make their careers. Almost half of theater managing directors with administration degrees reported that it was "very unlikely" that they would take jobs unrelated to the performing arts, as compared with only 16 percent of their colleagues. In the other fields, individuals with and without management degrees were about equally as likely to anticipate departure.

Theater managing directors with prior acting or technical experience appeared highly committed to the performing arts: proportionately just half as many as those who lacked such experience expected to leave the field. Similarly, orchestra managers with undergraduate or graduate degrees in music, or with experience in the arts (as artists or managers) before entering the orchestra field, were less likely than others to anticipate taking positions outside the performing arts. Finally, art museum directors with Ph.D.s were less likely than those without to expect to administer non-art museums, whereas those who had been curators were less likely than those who had not to anticipate accepting a position outside of museums or the visual arts.

In sum, these findings suggest that arts administrators with artistic backgrounds were somewhat more likely to have positive career expectations and less likely to anticipate leaving the arts than were those without such experiences. Nonetheless, there was no evidence that administrators with management degrees were any less committed to their fields than were those without such degrees, despite the fact that their opportunities outside of the arts may be greater because of their training.

Multiple Regression Analyses of the Predictors
Of Expected Departure from Work in the Arts
To examine the *net* influence of the factors discussed thus far (and of additional aspects of background and attitudes) on administrators' expectations of leaving the arts, we performed multiple regression analyses for each of the four fields to examine how various factors influence the loss of managerial talent while controlling for the effect of other variables.

Although age and seniority were largely unrelated to expectations of leaving the performing arts, age was the most powerful net negative predictor of expected departure for art museum directors, and years of experience in the arts before CAA work accounted for a substantial disinclination among CAA directors to leave the art field. Further, art museum directors who worked in other fields before going into the arts and those who had been curators were notably more likely than others to plan to take jobs outside the arts. (The latter finding contrasts with the results of analyses without controls.)

Career satisfaction, not surprisingly, strongly influenced responses for every group but the orchestra managers. Satisfaction with contacts with artists bore a notable negative relationship to expected exit among art museum directors and a modest negative relationship for CAA directors. Oddly enough, controlling for other sources of satisfaction, art museum directors who enjoyed contact with their trustees were substantially more likely to anticipate leaving the museum and visual arts worlds than those who did not.

Among resident theater managers only, women were substantially more

likely than men, other things equal, to anticipate leaving the performing arts. (Recall that it was in the resident theater field that women were most disadvantaged relative to men in their earning power.)

Controlling for other factors, theater and orchestra managers with management degrees were less likely than others to expect to leave the performing arts, whereas orchestra managers with highly educated parents, music degrees, and high levels of educational attainment were somewhat more likely than others to do so. Art museum directors who attended private schools and held Ph.D.s in art history were notably less likely than other directors to plan to work outside museums or the visual arts. And among the CAA directors, educational attainment modestly increased expected departure while college quality negatively affected it. Holding these and other factors constant, CAA directors with highly educated parents were less likely than others to expect to leave the arts, whereas those whose fathers or principal guardians were professionals or owners or top executives of major businesses were more likely to anticipate departure.

Conclusions

Insofar as managers' reports of their own satisfactions and expectations were guides to the extent to which fields were likely to retain administrative talent, none of these fields was in crisis, but, to varying degrees, each seemed likely to face challenges in the years ahead. Resident theaters may find it difficult to retain talented young men and, especially, women. Orchestras may have a hard time providing satisfactions for young managers and offering further career opportunities to successful managers of large institutions. Art museums appeared to face the fewest difficulties, but even here the most junior directors expressed less commitment than did more senior ones. Finally, local arts agencies are likely to encounter the most severe problems in attracting and retaining managerial talent: the most successful LAA directors may lack necessary opportunities for career growth; and members of the middle cohort appeared, from their responses, to be undergoing a crisis of confidence, reporting relatively low levels of satisfaction and high probabilities of leaving the arts.

Notes

1. Because of the special relationships between many local arts agency directors and their municipal governments, the results are not completely comparable for CAA directors and other respondents. More generally, without comparable questions regarding contacts with private foundations and corporations, it is difficult to interpret the relatively negative response to government, particularly since it is unclear which agencies (federal, state, local, or survey-toting recipients of federal grants like the author) respondents had in mind.

2. For the purpose of data analyses, the numbering of categories in the survey instruments, in which "1" = "very likely" and "4" = "very unlikely," has been reversed.

3

Training

As the number of arts organizations has grown and their complexity has risen, the need for skilled managers has become increasingly apparent. Many universities have founded arts management programs that train and certify administrators.[1] Service organizations and public agencies have sponsored internships and supported technical-assistance programs run by consulting firms and active arts administrators. Almost all the major service organizations conduct workshops and seminars for in-service managers. Advocates of different methods of management training have developed fervently argued and often persuasive rationales in behalf of their favorite approaches.

This discussion and activity has proceeded in a knowledge vacuum. Systematic information about how arts administrators learn their jobs, how they evaluate different training techniques, and what their perceived needs are—except for local-level needs-assessments and evaluations of specific programs—has been unavailable. The following discussion represents the first national study of the learning experiences of working arts administrators that permits comparison among artistic disciplines and explicitly distinguishes among several management functions in assessing the value of different training approaches.

None of these findings should be interpreted as reflecting definitively on the objective quality of any training method. First, they are all based on subjective opinions of arts administrators; thus, we cannot tell which methods best enhance administrative effectiveness because we have no way of knowing how effective these respondents are. Second, different organizations require their administrators to have different skills: financial manage-

ment ability may be especially crucial, for example, to an art museum director whose museum lacks a full-time assistant director for financial affairs. Third, assessments of different learning methods cannot be generalized to all sources of a given kind of training. There are good and bad consultants, good and bad administration courses, and good and bad internships. Finally, our methodology did not lend itself to an investigation of the ways in which administrators acquire, or fail to acquire, certain critical aspects of arts-administrative competence: sensitivity to the needs of artists and to the requirements of artistic work, and commitment to the core artistic missions of their organizations.

Levels of Preparation

Using a three-point scale ("1" = "good," "2" = "fair," and "3" = "poor"), respondents were asked to evaluate their own level of preparation in each of seven management functions at the time they assumed their first top administrative position (see table 3-1). Four of these functions (financial management, personnel management, board relations, and labor relations) are primarily internal. Three functions (planning and development, marketing and public relations, and—for art museum and CAA directors—government relations) concern management of the organization's external environment.

Surprisingly, few managers felt they were well prepared to assume many of these functions. For example, fewer than one third in any discipline believed their preparation in financial management was "good," whereas between one and two fifths in each field reported poor preparation. Indeed, only among the CAA directors, and only for planning and development and for marketing and public relations, did slightly more than half of the respondents report being well prepared for any management function; usually, most respondents characterized their preparation as "fair." Only in the field of labor relations (which may have been less important for administrators of smaller organizations, especially museums and CAAs) did more than two fifths of the administrators in each field regard their preparation as "poor."

What the data in this table suggest is that none of these artistic fields prepared prospective administrators satisfactorily for their first executive jobs. A substantial minority in each field felt inadequately prepared for one or more important administrative tasks, and only a minority in any field believed they were well prepared for many of their responsibilities. In particular, preparation for financial management and labor relations in each field appears to have been problematic, while readiness for board relations among theater managing directors, and for both government relations and

Table 3-1

Self-Evaluation of Preparedness at the Time Of First Top Managership, by Management Function (percent)

	Fiscal Mgmt	Personnel Mgmt	Board Relations	Planning and Dvlpmt	Marketing and Public Relations	Labor Relations	Govt Relations
Theaters							
Good preparation	27.45	42.57	30.69	37.62	39.60	20.00	NA
Poor preparation	25.49	13.86	29.70	23.76	16.83	45.26	
(Respondents)	(102)	(101)	(101)	(101)	(101)	(95)	
Art Museums							
Good preparation	25.60	30.40	45.83	32.52	29.27	15.25	21.95
Poor preparation	40.80	24.00	14.17	23.58	30.89	55.00	43.09
(Respondents)	(125)	(125)	(120)	(123)	(123)	(118)	(123)
Orchestras							
Good preparation	26.42	36.89	43.14	33.33	47.06	22.00	NA
Poor preparation	23.58	15.53	23.53	19.61	20.59	49.00	
(Respondents)	(106)	(103)	(102)	(102)	(102)	(100)	
CAAs							
Good preparation	29.46	39.84	42.64	52.71	53.13	11.02	37.01
Poor preparation	20.16	13.28	17.83	14.73	11.72	50.85	25.20
(Respondents)	(129)	(128)	(129)	(129)	(128)	(118)	(127)

NOTE: NA = not asked/not applicable.

marketing and public relations among art museum directors, was reported to be particularly low.

It is possible, of course, that some fields had already begun to address the problems by the time these surveys were conducted. If so, we would expect administrators in the most recent cohorts to have reported higher levels of preparation than did members of more senior cohorts. Although recollections are not always trustworthy—it would be better if someone had undertaken a comparable survey 15 years before—such data can at least provide some guide to changes over time.

The only discipline in which administrators reported becoming better prepared for the management functions described here during the professional lifetimes of current managers was the resident stage. For all functions but labor relations, the most recent entrants were more likely to report having been well prepared than were members of the two more senior cohorts. And for all functions but personnel management, they were less likely to term their preparation "poor."

By contrast, the percentage of art museum directors reporting poor preparation was higher for every function but personnel management among

the most junior cohort than among the preceding one (although lower in every case than the percentage for the most senior directors). Taken at face value, this suggests that preparation of museum directors improved markedly between the first and second cohorts but deteriorated somewhat among the most recent entrants. When one recalls that the recent professionalization occurring among art museum directors has had much more to do with art history credentials than with administrative ones, this pattern is not surprising.

If the younger cohort of theater managing directors felt better prepared for their first administrative posts, the opposite was true for orchestra managers: for every function but planning and development, the most recent entrants into the field reported lower levels of preparation than either of the preceding cohorts. By contrast, however, except for personnel management and labor relations, fewer members of the most recent cohort reported being poorly prepared than did members of the preceding cohorts.

Because most CAA directors were relatively new to their field, there was less reason to expect intercohort change in that field than in others. Yet members of the middle cohort reported better preparation in virtually every respect than did the more senior directors, many of whom were pioneers in agency management. And the most junior cohort felt better prepared than their immediate predecessors in financial management and in planning and development, but felt somewhat *less* well prepared in the areas of marketing and public relations, labor relations, and government relations.

These self-reports suggest that theater managing directors have become better prepared for their first top administrative posts during the careers of the survey respondents; art museum and CAA directors became better prepared between the times that the most senior and middle cohorts assumed top managerial posts, but readiness remained stable or declined thereafter; and the subjective readiness of orchestra managers for their first top positions seems to have declined.

Neither budget size nor career experience was systematically associated with managerial preparation in any of these four fields. Administrators with higher degrees in artistic majors reported lower levels of preparation for at least some functions in each field, but the differences were usually small. The absence of association between budget size and reported preparation in all fields but theater (where there was a negative association) is striking, for it suggests that lack of prior management training or experience has not been a serious impediment to administrative career success. Thus, it is not surprising that, as we shall see below, most arts administrators placed greater stock in on-the-job experience than in formal training, for the former has generally been responsible for their own achievements.

How Managers Learned

We did not ask administrators to assess their own current competence, because their responses would have been influenced at least as much by personality and expectations as by actual levels of skill. Still, it seems reasonable to assume that during the course of their careers almost all respondents learned something about each functional area. For each type of managerial responsibility, respondents were asked to indicate if they had used any of five training formats (on-the-job training, professional workshops and seminars, university arts administration courses, university general management courses, and consultants) to learn that function; and, if so, to assess the value of their experiences. Table 3-2 below reveals the extent to which top administrators in each field had used each training format to learn each management function.[2]

On-the-job training was far more frequently cited than any other kind in familiarizing arts administrators with the functions they performed. More than 85 percent of each set of administrators reported receiving on-the-job training for every skill about which they were asked. (The single exception—labor relations for CAA directors—was a skill of little salience to most respondents in this group.) Workshops and seminars were a distant second, their use reported by more than 40 percent of all but the art museum directors for learning about personnel management, fiscal management, board relations, planning and development, and marketing and public relations. Some managers in all fields, but especially theater managing directors, reported using consultants for a range of purposes, most frequently planning and development, and fiscal management.

Relatively small minorities in each field received training from university arts administration and general management courses, especially in the area of financial management. Performing arts administrators, above all orchestra managers, were more likely than others to report attending arts administration and general management courses, whereas local arts agency directors were least likely to have sought instruction in such university programs.

Use of university arts administration and general management courses, as well as attendance in workshops, increased markedly among the more junior cohorts in each field but the art museums. Although even among the newcomers only a minority received such training, if the trend were to continue it would represent a significant change in the way arts administrators learn their jobs.

Global Assessments of Selected Training Methods

Respondents were asked to indicate their "general assessment of the relative value" of several forms of "management training" for administrators in

45

Table 3-2

Use of Five Learning Methods by Function, by Field (percent)

Discipline	Fiscal Mgmt	Personnel Mgmt	Board Relations	Planning and Dvlpmt	Marketing and Public Relations	Labor Relations	Govt Relations
Theaters (102)*							
On the job	96.08	97.06	99.02	96.08	95.10	91.18	NA
Professional workshops/seminars	49.02	28.43	46.08	53.92	55.88	17.65	
University arts administration courses	23.53	15.69	14.71	17.65	18.63	14.71	
University general management courses	28.43	22.55	12.75	17.65	17.65	11.76	
Consultants	56.86	36.27	44.12	47.06	4.90	33.33	
Art Museums (125)							
On the job	92.80	92.80	90.40	92.80	92.80	83.20	91.20
Professional workshops/seminars	36.80	39.20	24.00	34.40	28.80	21.60	27.20
University arts administration courses	16.80	15.20	15.20	18.40	12.80	14.40	12.80
University general management courses	22.40	21.60	12.80	16.80	15.20	17.60	12.80
Consultants	36.80	32.80	0.00	39.20	38.40	32.00	24.80
Orchestras (106)							
On the job	99.06	99.06	95.28	96.23	95.28	89.62	NA
Professional workshops/seminars	51.89	39.62	44.34	49.06	55.67	34.91	
University arts administration courses	22.64	17.92	16.04	19.81	19.81	18.87	
University general management courses	33.02	17.92	14.15	22.64	24.53	19.81	
Consultants	36.79	23.58	26.42	38.68	36.79	33.02	
CAAs (129)							
On the job	89.15	92.25	93.02	89.15	88.37	65.12	86.82
Professional workshops/seminars	45.74	31.78	44.96	58.91	57.36	14.73	24.03
University arts administration courses	18.60	9.30	10.85	15.50	12.40	6.20	10.85
University general management courses	25.58	16.28	7.75	21.71	18.60	8.53	8.53
Consultants	27.91	16.28	22.48	42.64	31.01	10.85	17.05

NOTES: NA = not asked/not applicable.

* Figures in parentheses are the number of respondents for each group.

their own field. The purpose of this question was not to assess the actual value of these approaches to management training, since responses were sought from individuals who had not experienced each approach firsthand, and since meaningful evaluations require some specificity as to training goals. (For example, a given format may be superb for learning financial management but poor for learning how to use a board of trustees.) Rather, this question was intended to tap the general reputation of each training method among administrators in each field. We shall see in the next section that reports of administrators who had used each training method diverged in important ways from the reputations of these approaches among administrators as a group.

The methods of training evaluated were university arts administration training and university general management training undertaken prior to first top administrative position; internships; university arts management courses (or "theatre-management," as it read in the instrument sent to theater managing directors) and university general management courses undertaken in-service; professional workshops or seminars; consultancies by full-time management consultants; consultancies by other top administrators in the respondent's field; and "learning by doing on the job." In addition, a space was left blank for respondents to add alternative approaches.

After each method was ranked on a scale of 1 to 10 (with "1" = "most valuable"), the scale was collapsed into three categories, for which "1" indicated a rank of 1 to 3, "2" indicated a rank of 4 to 6, and "3" indicated a rank of 7 to 10. The percentage of administrators in each field ranking each learning format in the top and bottom of the three collapsed categories is reported in table 3-3.

Most striking about the data that emerged was the relative consensus among managers in these fields about the general value of these approaches.[3] On-the-job training and internships were valued very highly, as were workshops to a lesser extent. Apparently, in these fields, lack of formal training has been no obstacle to success. Whereas peer consultants and arts administration courses had both proponents and detractors, general management training met with much skepticism, and consultancies by management consultants were accorded the least stature as a management training tool.

There were few differences by cohort among administrators of art museums, orchestras, and CAAs; however, the most junior cohort of theater managing directors reported more positive evaluations of arts administration training programs, and of preservice general management training in particular. Whereas the most senior cohort in this field ranked the latter below even management consultants, 40 percent of the most recent entrants rated such training among the top three. By contrast, the reputation of

Table 3-3

Evaluation of Learning Methods,[a] by Field (percent)

Field	A1	G1	IN	A2[b]	G2	WS	MC	PC	OJ
Theaters									
Method 1-3	41.11	25.33	54.43	34.48	12.20	33.67	20.43	41.11	79.31
Method 7-10	28.89	30.67	12.92	22.41	36.59	21.43	47.31	25.56	9.20
(Respondents)	(90)	(75)	(79)	(58)	(41)	(98)	(93)	(90)	(87)
Art Museums									
Method 1-3	41.05	29.91	58.68	40.00	27.83	38.14	19.13	32.48	80.65
Method 7-10	29.06	31.62	16.53	20.00	33.04	27.12	46.96	33.33	8.06
(Respondents)	(117)	(117)	(121)	(110)	(115)	(118)	(115)	(117)	(124)
Orchestras									
Method 1-3	35.58	27.18	60.78	31.07	21.57	40.78	14.85	26.47	78.64
Method 7-10	30.77	37.86	8.82	22.33	41.18	18.45	61.39	43.14	10.68
(Respondents)	(104)	(103)	(102)	(103)	(102)	(103)	(101)	(102)	(103)
CAAs									
Method 1-3	28.80	26.40	46.77	39.84	23.20	45.31	15.87	37.01	65.89
Method 7-10	39.20	37.60	22.58	19.51	34.40	20.31	50.00	31.50	12.40
(Respondents)	(125)	(125)	(124)	(123)	(125)	(128)	(126)	(127)	(129)

NOTES: [a] A1 = university arts administration training before becoming top administrator; G1 = university general management training before becoming top administrator; IN = internships; A2 = university arts administration training in-service; G2 = in-service university general management training; WS = professional workshops and seminars; MC = full-time management consultants; PC = peer consultations; OJ = learning by doing on the job.

[b] For theaters, A2 = in-service university theater management training.

workshops seemed to be experiencing a concomitant decline, with more than one third of the most recent entrants to the field, compared with just 14 percent of the more senior managing directors, rating workshops and seminars in the bottom categories. Moreover, the most junior managing directors also held peer consultancies in lower esteem than did members of the most senior cohort. Thus, consistent with the increased use of academic administration training among theater managing directors is an improved reputation for such training programs and a devaluation of peer instruction through workshops and consultancies.

Evaluation of Learning Methods by Managers Who Had Used Them

We now consider the utility of specific training formats for learning about selected management functions, as evaluated by administrators who had in fact used them themselves for these purposes. Even with this added specificity, however, these evaluations must be interpreted with caution. First, characterizations of training methods are broad and include many diverse programs. If, for example, one set of administrators reports finding a consultant more useful for learning about labor relations than does another set, it may be that the more positive respondents used superior consultants. Second, many of these findings are based on assessments by very small sets of experienced managers.

Respondents were asked, for each of seven management functions, to rate any of five training formats they had actually used as being ''very useful,'' ''somewhat useful,'' or ''not useful.'' The training formats were on-the-job training, workshops and seminars, consultants, university arts administration courses, and university general management courses. All findings reflect *only* the responses of administrators who had actually used the training format for the purpose at hand. Intrafield differences by cohort, budget size, and experience are not reported here because the subgroups generated by such distinctions were too small for results to be meaningful.

In general, administrators ranked on-the-job training particularly high as preparation for financial management, personnel management, and board relations, and relatively low as background for labor relations. Workshops were reported to be relatively useful ways for learning about financial management, planning and development, and marketing and public relations, but less useful for learning about board relations and labor relations. Consultants were seen as very useful for training in planning and development and in marketing and public relations; and less useful for learning about labor relations and, especially, personnel management. Arts administration and general management courses were both given moderate marks on marketing and public relations and considered not very useful

for training in labor relations or board relations. In general, respondents had few positive evaluations about most methods for learning about labor relations and board relations; and reported positive evaluations of a range of sources of information about marketing and public relations, financial management, and planning and development.

Administrators from different fields varied in their assessments of different learning methods. Art museum directors tended to be generally less likely than members of other groups to rate experiences as very useful, while CAA directors were somewhat more likely, other things equal, to express positive sentiments. Orchestra managers were particularly positive, as a group, in their evaluation of workshops, while CAA directors were unusually positive in their assessment of general management and, particularly, arts administration programs.

Conclusions

These specific evaluations by administrators who had experience with different forms of training differed from the global evaluations by all administrators in two notable respects. Although the global reputation of consultants among all administrators is quite low, those managers who actually used consultants for various purposes were quite satisfied. By contrast, despite the relatively high ratings that arts administration programs were given by administrators on the whole, actual users found them to be relatively unhelpful for most purposes. (Paradoxically, the one exception to this, the CAA directors, are in the field that, as a whole, gave arts administration courses the lowest global evaluation.) These findings suggest that generalized reputations of training programs may be poor guides for decisions by either policymakers planning programs or aspiring administrators seeking instruction.

Notes

1. University of Wisconsin Center for Arts Administration, *Survey of Arts Administration Training 1985–86* (New York: American Council for the Arts, 1984).

2. For each function, respondents were asked to indicate in one column which of the five learning formats they had used, and to assess, in columns to the right, their experiences for *only* those methods they had used themselves. However, most respondents failed to use the first column to indicate explicitly the methods they had used, and most simply circled assessments to the right of some of the learning formats. In coding these responses, we assumed that, where only some assessments were circled, these learning formats had been used, and that those formats for which no assessments were offered had not been. Where all assessments were circled for all functions, we inferred that the respondent had misunderstood the instructions, and we treated the responses as missing data. In the few cases in which a respondent circled some of the numbers next to training methods in the first column, but assessed each training method in the columns to the right, only those assessments of formats for which use was indicated in the first column were coded. In calculating the percentage of respondents who had used a given learning format, the base used was the largest number of respondents to any question in the first part of this section of the survey, which requested information regarding level of preparation for each function.

3. For reasons that are not apparent, theater managing directors alone showed a high degree of selective nonresponse to these questions. Consequently, data for these respondents must be interpreted with caution.

4

Professional Participation And Attitudes Toward Professionalism

Sociologists define *professionalism*[1] as a form of self-organization that enables practitioners of an occupation to defend the importance of their contribution and the legitimacy of their decisions. What Magali Sarfatti Larsen has called "the professional project" involves several dimensions: the development by practitioners of a cognitive basis for specialism that is seen as unique and not easily learned; the development of university programs, run by professionals, that control the certification of practitioners; the emergence of professional associations and the consignment to peers of the right to admit individuals to the practice of an occupation and to set and enforce ethical standards; and the establishment of at least some autonomy of professionals from the organizations in which they are employed.[2]

In this view, professionalism has two sides, one ideological and cognitive, the other behavioral and organizational. The role of the first is to establish the legitimacy of professional claims to authority, autonomy, and expertise. The set of attitudes associated with this side of professionalism usually includes

- Claims to authority based on knowledge and expertise;

- A commitment to the importance of university training programs that provide needed credentials for entry into the field;

- The belief that the expertise needed for professional practice cannot be acquired solely through formal means;

- The belief that professional standards can best be set and enforced by other professionals;

- A commitment to these professional standards, extending to a willingness to place the common good of the profession above the specific good of the employing organization when these interests conflict; and

- A concurrent commitment to the community of professionals, involving orientations that are "cosmopolitan" rather than "local."[3]

The role of the second side—behavioral and organizational—is to provide a framework in which professionals can interact with their peers, learn about new developments in their fields, develop reputations that can aid them in seeking professional advancement, and contribute to the public acceptance of their professional claims to expertise and authority. Components of this side include

- Participation in professional activities and organizations, particularly on the regional and national level;

- Reading of periodicals and other materials about the profession and professional practice;

- Acquisition of university training for professional practice;

- Attendance at professional conferences and similar gatherings; and

- Maintenance of strong ties and friendships with professionals employed in organizations other than one's own.

Several sets of questions we posed to the arts administrators bear on the issue of professionalism, as so defined. The questions, which differed from field to field, were based on reports in professional periodicals and discussions with managers, and were reviewed by administrators, policymakers, and service organization staff. In several cases, opinion questions were modeled on standard items used in other research on professionalism.[4] The first part of this chapter is devoted to behavioral, the second to attitudinal, professionalism.

Behavioral Professionalism

Participation in Professional Activities
Administrators in each field were asked whether or not they had participated in a wide range of professional activities, including membership in service and professional associations; service as officers, board members, or committee members in such associations; service on federal, state, and local

government arts-related panels and commissions; attendance at professional and service organization conferences; reading of periodicals related to their work; and friendship with other professionals.

All administrators reported engaging in a wide range of professional activities, although, as a group, art museum directors reported a somewhat broader and orchestra managers a somewhat narrower range of activities than did other administrators. In addition to their principal service organizations, almost half of the theater managing directors were members of the League of Resident Theaters (LORT). Almost three quarters of the art museum directors belonged to the Association of Art Museum Directors (AAMD), and almost half belonged to the College Art Association. Among community arts agency (CAA) directors, two thirds reported membership in the American Council for the Arts (ACA) and one third were members of the Association of College, University, and Community Arts Administrators (ACUCAA).

Relatively few administrators in any field reported serving as officers or as board or committee members of such organizations. Among art museum directors, one in six had been AAMD officers and over half reported AAMD committee membership. Among the other administrators, however, board membership only ranged from 10 percent for theater and CAA directors (in LORT and the National Assembly of Community Arts Agencies [NACAA], respectively) to 14 percent for orchestra managers (in the American Symphony Orchestra League); and committee membership was just a bit higher, averaging about one manager in five for each group. Some managers in all fields also reported serving in state or regional service or professional organizations.

All but the CAA directors were asked about participation on federal grant-review panels. (At the time of the survey, no federal program was explicitly aimed at supporting CAAs.) Almost 40 percent of the art museum directors reported serving on panels of the National Endowment for the Arts Museum Program during the previous five years, more than 25 percent had served on other Arts Endowment panels, one third had served as reviewers or panelists for the National Endowment for the Humanities, and almost one quarter had reviewed for or advised the Institute for Museum Services. By contrast, the percentage of orchestra or theater administrators who reported having served on their respective discipline panels or on other Arts Endowment panels was fewer than 10 percent for each. The reason for this discrepancy between museum and performing arts administrators would seem to be that art museum directors are the central actors in their institutions, commanding (with only a few exceptions) primary responsibility for both the aesthetic and administrative functions. By contrast, although many theater and orchestra managers are experienced in drama

or music, artistic directors play the prime aesthetic roles in their organizations.

Nonetheless, performing arts managers are often present on peer-review panels at the state level: almost one third of the theater managing directors and over one fifth of the orchestra managers reported serving on state arts agency (SAA) discipline panels. In addition, two fifths of the art museum directors reported having served on SAA museum panels, and almost 50 percent of the CAA directors acknowledged serving on an SAA panel during the past five years. CAA directors were also more likely than other administrators to have served on some other state government panel, commission, or committee concerned with the arts.

In summary, respondents worked in a wide variety of capacities that took them beyond the bounds of their own institutions. Many of their activities focused on the regional, national, or state level. Some involved association with other professional arts administrators; others involved contact with government agencies; and still others brought them into contact with universities, community organizations, and the broader public. Panel participation on the national level was most common for the art museum directors, most of whom were art historians, and these administrators were also more likely to lecture at universities, to advise businesses and foundations about contributing to the arts, and to serve on professional association committees. And while CAA directors reported being especially involved at the local and state levels in both public-sector and private-sector arts activities, all managers were active on SAA panels and in state and regional professional associations, and all were substantially involved in university and workshop lecturing, as well as in other activities.

Conference Attendance
Patterns of conference attendance varied from field to field, in part depending on the number and frequency of events. Most top administrators in all fields had attended at least one meeting of their field's primary service organization during the previous five years. Specifically, about two thirds of the art museum directors reported attending meetings of the American Association of Museums (AAM), an equal proportion of theater managing directors reported attending national meetings of the Theatre Communications Group (TCG), and over three quarters of the CAA directors had been to at least one NACAA national convocation. Finally, fully 89 percent of the orchestra managers had attended one or more ASOL national conferences, and over half reported having been to four or five between 1976 and 1980.

Other meetings also attracted respondents during the previous five years. Among theater managing directors, more than half had attended conferences

of the Foundation for the Extension and Development of the American Professional Theatre (FEDAPT), almost half had attended an annual meeting of LORT, and the same proportion had attended a state or regional theater conference. Similarly, almost two thirds of the art museum directors reported having attended one or more AAMD annual meetings, just over half had attended a national conference of the College Art Association, and almost half reported attending a convocation of a state or regional museum association. More than half of the CAA directors had attended a conference of the American Council for the Arts and a similar percentage had been to at least one ACUCAA conference. Nearly three quarters of the orchestra managers reported having attended one or more of ASOL's regional workshops. In sum, although the fields varied in the extent to which conference attendance was focused on a single national service association, arts administrators actively attended conferences that enabled them to develop their professional skills and extend their professional networks.

Periodical Reading

A more passive form of professional engagement is the reading of periodicals that treat issues important to one's field. Respondents were asked whether they read selected periodicals "never," "occasionally," or "regularly." Those periodicals that were read regularly included some, like the newsletters and magazines of the service organizations (e.g., NACAA and NASAA newsletters), that carried articles about management, artistic accomplishments, and personnel movements within each field. Others (e.g., *Theatre* or *Art Journal*) emphasized artistic developments, whereas still others (*Cultural Post* or *Arts Reporting Service*) focused on the relationship between government and the arts. And a few provided general coverage of the arts (e.g., *Sunday New York Times Arts and Leisure Section*).

Most administrators in every field reported reading regularly the publications of their primary service organization. These included the AAM's *Museum News*, read by just over half of the art museum directors, and ASOL's *Symphony*, read by nearly all of the orchestra managers. Managers varied in the extent to which they read periodicals of largely aesthetic interest: just 10 percent of the theater managing directors read *Theatre* regularly, whereas over 25 percent of the art museum directors reported regular readership of *Art Bulletin*.

Respondents also varied in the extent to which they read other materials relevant to their fields or to the arts in general. For example, more than one third of the theater managing directors reported reading the weekly edition *Variety* on a regular basis, compared with just a handful of the orchestra managers (who were even less likely to read *Billboard*, which covers recording industry news). About half the CAA directors said they read *American*

Arts regularly, compared with just about one in eight administrators in the other fields. Orchestra managers and CAA directors were most likely to read *Cultural Post* and the *Arts Reporting Service*, while art museum directors were least likely to do so. And performing arts administrators constituted the most devoted readership of the American Arts Alliance's *Legislative Reports*.

Friendships

Professions are commonly believed to absorb more of an individual's time and commitment than other occupations. Consequently, respondents were asked, "Of your five closest friends, how many work in your own field?" Administrators of the resident theaters were strikingly more likely than managers in other fields to number colleagues among their closest friends: over 40 percent reported that three to five of their closest friends worked in their field, whereas only about 10 percent found none of their five closest friends so involved. By contrast, only about 17 to 25 percent of all other respondents said three to five of their closest friends were colleagues, while 30 to 40 percent found no colleagues among their five closest friends. Given the high average levels of professional experience among the art museum directors, their responses were somewhat surprising. The high degree of intrafield friendship among the theater managing directors, however, may be related to the greater geographical concentration of theater activity than of activity in the others fields.

Variation by Cohort and Organization Size

In all four fields, the link between seniority and professional participation was found to be inconsistent, although in general, it was strongest among the orchestra managers and weakest among the art museum directors. In all disciplines, the more senior managers were far more likely to report participation as officers, board members, or committee members in national service organizations or on national panels, whereas differences in participation by cohort were far smaller at the state and regional levels (although, among orchestra managers, such differences remained notable). By contrast, local activities were sometimes favored by members of the more recent cohorts.

More senior managers among the theater, museum, and CAA administrators were also more likely to attend national conferences. At the same time, the most junior cohorts of orchestra managers and CAA directors—but not of theater managing directors—were somewhat less likely to read many periodicals than were their more senior colleagues.

In the art museum field, however, junior cohort participation was far greater than that in other fields, particularly with regard to invited or ap-

pointive positions such as reviewer or adviser for the National Institute of Museum Services. Yet these more junior directors were less likely than others to attend AAM conferences and to read *Museum News*. Three reasons may account for these differences. First, members of the junior cohort of art museum directors had been top executives longer than had recent administrators in any other field. Insofar as time (rather than position in a queue) is related to participation, they would be expected to participate more. Second, cohort was less closely related to organization size in the art museum field than it was in any other; insofar as managers of larger organizations participated more than those of smaller ones, we would expect the junior cohort of art museum directors to have been less affected. Finally, the newest art museum directors were more likely than their predecessors to hold Ph.D.s and to have taught in universities; thus, their professional commitments may have been directed more to the worlds of art history and *art* museums than to the museum world in general.

Organization budget size appeared to bear a similar relationship to professional participation as that of tenure in the field. Generally speaking, the wider the geographic scope of an activity and the more participation was invited rather than voluntary, the greater the tendency for managers of larger organizations to participate more than those of smaller ones. This tendency was exceptionally strong in the orchestra field, somewhat less so among CAA directors, and weakest, although still notable, in the art museums.

For example, managing directors of small theaters were no less likely than were directors of larger theaters to participate in state, local, and regional activities; to attend local or regional conferences; or to read widely in professional periodicals. Art museum size was similarly unrelated to whether a director participated in National Endowment for the Arts panels other than those of the Museum Program, reviewed for the Humanities Endowment or the Museum Services Institute, or attended AAM meetings. Indeed, directors of smaller museums were more likely than directors of larger ones to be involved in many state and local activities (including membership in SAA panels). Somewhat surprisingly, directors of the larger museums tended to read less widely in their field's periodical literature and to recruit fewer friends from the museum field than did their smaller budget colleagues. It is possible that directors of large museums were so well integrated into the field that they did not need to read to keep up with events; but it is also possible that participation in the university-centered world of art history has created stronger professional networks among directors of small museums (many of which are university museums) than among those of larger institutions.

By contrast, professional participation was strongly related to organiza-

tion size among CAA directors and orchestra managers. For the former, it may have been that, in the absence of major variation in experience in the field, organizational budgets were the principal axis of differentiation; thus, directors of large CAAs were more active not only at the national level but also in most state and local activities and more active not only in invited participation but in voluntary conference attendance as well. Among orchestra managers, those with the smallest orchestras were less integrated into the field with respect to every measure of participation except membership in SAA panels (other than orchestra panels) and certain local activities. They were also less likely to attend national ASOL meetings (but not ASOL regional workshops), to read regularly most of the publications listed on the survey, and to have many close friendships with other orchestra colleagues.

In summary, then, more experienced managers and administrators were more active participants in professional activities in all fields, especially when those activities were national in scope and were invited (or elective) rather than voluntary. In most fields, younger managers and those of smaller organizations appeared active in state and local affairs, suggesting an informal apprenticeship system with interorganizational professional careers. This system appeared strongest in the art museum field, where differences in professional participation based on organization size and length of experience were weakest, and it appeared weakest in the orchestra field, where such differences were strongest and where managers of the smallest organizations were also less integrated than others in terms of several informal and voluntary forms of professional participation.[5]

Attitudinal Professionalism

Professional attitudes are characterized by adherence to claims about the qualities of both individual practitioners and the occupational community as a whole. With respect to the individual, professionalism includes an emphasis on expertise as the basis of authority; claims of altruism, disinterestedness, or public spiritedness; and a view of career advancement through professional practice in several organizations rather than through promotion in a single organization. With respect to the community, professionalism entails loyalty to the professional community and its standards being placed above loyalty to one's employer; an emphasis on the collective action of professionals to enforce professional ethical standards; and a commitment to use professional associations to increase the legitimacy of professionals with the general public and with specific constituencies, including government.

Three multifaceted questions tapped these individual and collective com-

ponents of professionalism. The first question asked managers to assess the relative importance of several qualities or criteria that could be used to select the chief administrator of an organization like their own. The second question asked them to rate the relative importance of a number of functions that service organizations might perform in their field. The third question—actually, a set of several paired statements between which respondents had to choose—was designed to tap their attitudes toward specific aspects of the managerial role and organizational mission.

At the individual level, respondents' attitudes toward the importance of managerial expertise were reflected in their ratings of management experience, formal training in administration, ability to prepare a budget, marketing experience, grantsmanship ability, and private fund-raising ability as managerial qualifications. Their attitudes were reflected as well in how they rated the importance of keeping managers informed about new administrative techniques and of providing training opportunities as functions of service organizations. Two forced-choice pairs also addressed the issue of managerial expertise: one asked respondents to assess the relative importance of artistic and administrative experience as background for jobs like their own; and one (addressed only to orchestra and CAA administrators) asked about the relative utility of volunteers and trained paid employees. (In such fields as social work, exponents of professionalism have opposed the use of volunteers on the ground that they lack appropriate training and expertise.) As for the other two characteristics of individual professionalism, the emphasis on disinterestedness and altruism was tapped by a forced-choice question asking respondents to assess the extent to which professional administrators in their fields were motivated by extrinsic, as opposed to financial, rewards; and the focus on interorganizational careers was addressed by asking respondents to assess the importance of enhancing career opportunities as a function of service organizations.

Several other items were used to assess the extent to which respondents felt a strong commitment to their professional communities. They were asked to rate the importance of a manager's ''standing in the field'' as a criterion for selecting top executives for an organization like their own. In the forced-choice format, they were asked to decide whether administrators like themselves owe a responsibility to the field as a whole even when it runs against the short-range interests of their own institutions. Willingness to vest social control over the activities of individual managers in the professional community was tapped by respondents' assessments of the importance, as functions of service organizations, of establishing standards of ethics for managers and of preventing unqualified persons from serving as arts administrators. In addition, museum directors were asked, in forced-choice format, about their attitudes toward museum accreditation and, in

a separate question, about the proper agency to enforce museum ethical standards. Finally, their opinions about the use of service organizations to represent their profession to those outside their field were tapped by the importance they attributed to enhancing the public status of their organizations or professions, representing the field to public agencies, and advocating legislation in the interests of the arts.

It should be noted that all these questions assessed attitudes only toward *managerial* professionalism, and not toward artistic or scholarly professionalism, as might be espoused by theater artistic directors or academically oriented museum directors. This is yet another reason why professionalism, as defined here, must not be confused with either effectiveness or virtue.

Criteria for Selecting Administrators

Respondents in each field were asked to rate criteria for selecting a chief administrator for an organization like their own as "unimportant," "somewhat important," or "very important." Patterns of response were quite similar from field to field (see table 4-1).

Given the diversity of organizational missions and structures among the four fields, the degree of consensus on the question of what makes a good manager was high. Administrators in all groups reported that they would choose replacements for themselves who had management experience; tact, refinement, and style; and the ability to prepare a budget; and who appreciated the work of the artists or artistic experts whom they managed. In none of these fields were respondents very concerned about the standing of candidates in the field as a whole, whether they had received formal training in administration, or whether they had training or experience in educational work in their field.

Functions of Service Organizations

Respondents demonstrated similar consensus in assessing the importance of 10 potential functions of service organizations in their fields (see table 4-2). On the whole, managers agreed strongly that service organizations should take stands on legislation relevant to their fields and represent the field to public agencies concerned with the arts. Over two thirds of the performing arts administrators also considered status enhancement a "very important" function. Also considered among the most important functions were the need to keep members abreast of current management techniques, and the provision of training opportunities for managers.

By contrast, relatively few respondents in any field considered it a "very important" function of service organizations to prevent unqualified persons from holding jobs (an important function in the classic professions of

Table 4-1

Criteria Considered "Very Important" for Selecting A Chief Administrator, by Field (percent)

Criteria	Theaters	Art Museums	Orchestras	CAAs
Management experience	74.19 (103)*	85.61 (124)	85.85 (107)	92.23 (132)
Tact, refinement, style	81.55 (103)	88.71 (124)	90.57 (106)	75.76 (132)
Ability to prepare a budget	85.44 (103)	56.45 (124)	86.92 (107)	81.06 (132)
Appreciation[a]	83.50 (103)	64.23 (123)	82.24 (107)	67.42 (132)
Marketing	51.46 (103)	NA	60.75 (107)	NA
Private fund-raising ability	58.25 (103)	49.59 (123)	42.99 (107)	NA
Grantsmanship ability	61.17 (103)	28.46 (123)	46.73 (107)	56.06 (132)
Commitment to outreach	36.89 (103)	26.83 (123)	46.73 (107)	58.78 (131)
Knowledge[b]	24.27 (103)	45.16 (124)	44.86 (107)	32.06 (131)
Standing in the field	9.71 (103)	34.68 (124)	17.76 (107)	24.24 (132)
Formal training in administration	14.71 (102)	8.87 (124)	15.89 (107)	18.94 (132)
Educational training[c]	3.88 (103)	12.20 (123)	8.49 (106)	9.85 (132)

NOTES: Criteria are ranked in order of importance according to the average percent of respondents reporting "very important" across all four fields.

NA = Not asked/not applicable.

[a] For theaters, 'appreciation of the dramatic art'; for museums, 'connoisseurship'; for orchestras, 'appreciation of classical music'; for CAAs, 'appreciation of the arts.'

[b] For theaters, 'knowledge of the dramatic literature'; for museums, 'scholarship'; for orchestras, 'knowledge of the symphonic repertoire'; for CAAs, 'familiarity with the community arts scene nationally.'

[c] For theaters, 'training or experience in theater education'; for museums, 'training or experience in museum education'; for orchestras, 'training or experience in music education'; for CAAs, 'training or experience in arts education.'

* Figures in parentheses are the number of respondents for each item.

medicine and law), or, except in the case of CAA directors, to bring together administrators and colleagues from similar fields into one professional community.

If many art museum directors looked toward their service organizations to set ethical standards, fewer were willing to let such associations enforce them. Almost half of the art museum directors reported that ethical standards should be enforced by each museum's board of trustees. Slightly fewer would have them enforced by either the AAM or the AAMD, while fewer still suggested some other method of enforcement. None, however, recommended that such standards be enforced by government agencies that support museums.

Forced-Choice Responses
For each of the forced-choice questions, respondents were asked to choose one of two conflicting statements and to indicate whether making the choice was "very difficult," "somewhat difficult," or "easy." For each question, combining the choice and the estimate of difficulty yielded a scale ranging from "1" (easy choice of first alternative) to "6" (easy choice of second alternative).

Respondents were asked to choose between two statements, one of which asserted that "while business sense is useful, it is essential that" administrators in the respondent's discipline "have strong artistic backgrounds," while the other stressed the importance of "a strong background in management." From 70 to 80 percent of all groups but the art museum directors strongly favored the management alternative, while the same proportion of the art museum directors thought an artistic background was more essential. This striking difference reflected the academic background of most art museum directors, who appeared to offer their professional allegiance more to art-historical than to administrative standards.

Asked to choose between one statement asserting that "nonmonetary rewards make up for the low salaries" of managers in their fields and another stating that "salaries are so low . . . that many dedicated managers are leaving the field for more remunerative work," more than half of the (better-paid) art museum and orchestra administrators chose the first option, compared with about 40 percent of the theater managing directors and just over one in five CAA directors. Respondents were also asked to choose between one statement asserting that administrators of several kinds of arts organizations were members of the same profession and a second asserting that "I find that I have little in common" with members of these other groups. The reference group for theater and orchestra administrators was managers in all the performing arts; for art museum directors, it was people in all kinds of museums; and for the CAA directors, it included administrators

Table 4-2

Service Organization Functions Considered "Very Important," by Field
(percent)

Functions	Theaters	Art Museums	Orchestras	CAAs
Initiating or taking stands on legislation in areas of interest to the field	79.00 (100)	87.20 (125)	85.19 (108)	71.54 (130)
Representing the field to state and federal agencies concerned with the arts	72.78 (101)	75.20 (125)	83.18 (107)	78.29 (129)
Enhancing the status of the field in the eyes of the public	67.33 (101)	47.11 (121)	66.67 (108)	58.46 (130)
Keeping members/professionals abreast of current management techniques	61.39 (101)	43.59 (117)	71.03 (107)	54.20 (131)
Providing training opportunities for administrators	53.47 (101)	30.77 (117)	65.74 (108)	67.42 (132)
Setting standards of professional or managerial ethics	45.54 (101)	86.29 (124)	45.37 (108)	38.93 (131)
Facilitating career development through fostering contacts with other administrators in field	38.61 (101)	34.40 (125)	40.74 (108)	38.46 (130)
Exercising leadership to make the field more relevant and accessible to disadvantaged groups	18.81 (101)	18.40 (125)	23.15 (108)	38.17 (131)
Bringing together administrators and colleagues from similar fields into one professional community	14.84 (101)	17.60 (125)	7.41 (108)	44.27 (131)
Preventing unqualified persons from serving as administrators	14.29 (98)	21.01 (119)	20.37 (108)	23.66 (131)

NOTES: Functions are ranked in order of importance according to the average percent of respondents reporting "very important" across all four fields.

Figures in parentheses are the number of respondents for each item.

of all kinds of arts organizations. CAA directors and orchestra managers were most inclusive, with more than 90 percent of each choosing the first alternative, as did nearly as many theater administrators. By contrast, almost half of the art museum directors reported having "little in common" with directors of other kinds of museums.

In the fourth forced-choice question, respondents were asked to choose between the statement that an administrator should always act in the best interest of his or her organization, even when the action is not in the best interest of the field as a whole; and a second statement asserting the reverse. Only among the CAA directors did a majority of respondents choose the second, more classically professional, alternative. Majorities of the other respondents (from 58 percent of the art museum directors to over 75 percent of the orchestra managers) opted for the well-being of their organizations. (Fewer respondents in any discipline reported making this choice "easily" than any other forced-choice item described in this section.)

Finally, orchestra managers and CAA directors were asked to choose between one statement asserting that volunteers are intrinsically valuable and another suggesting that they are a necessary evil that should eventually be replaced by paid staff; respondents in both fields favored the pro-volunteer choice almost unanimously. Similarly, more than 90 percent of the art museum directors chose a statement favoring museum accreditation over one opposing it.

Variation by Cohort
Newcomers to the resident stage differed from more senior managers in several respects. They were only one third as likely to consider knowledge of the dramatic literature a very important qualification for their job, whereas one in five of them, compared with *no* respondents among the most senior cohort, considered formal training in administration to be very important. The more junior managing directors also considered it somewhat more important than did their senior colleagues for service organizations to keep managers abreast of recent management techniques and to provide training opportunities. The percentage who deemed an artistic background more essential than a management background also declined steadily with cohort: from almost one third of the most senior managing directors to less than a quarter of the middle cohort and just 13 percent of the newest entrants. In short, these patterns seem to reflect a growing managerial orientation on the part of more junior theater administrators, consistent with the changes in training and background described in earlier chapters.

The responses among junior art museum directors reflected similar changes in that field. The most recent entrants were less likely (just over 50 percent, compared with about two thirds in each earlier cohort) to con-

sider connoisseurship a "very important" criterion for selecting a director, whereas they, too, were considerably more likely (almost one quarter compared with none) to rate formal training in administration as "very important." The importance accorded fund-raising and budgeting as managerial qualifications also rose monotonically with cohort, and more than 50 percent of the junior cohort—twice as many as in the most senior cohort and five times those in the middle—included "commitment to outreach" among the important criteria. The most junior directors were also twice as likely to stress the value of service organizations in "keeping museum professionals abreast of current management techniques"; and just two thirds of the two more recent cohorts, compared with more than 90 percent of the most senior, placed more importance on scholarly and curatorial backgrounds for directors than on managerial backgrounds.

Although the orientation of the less senior directors was more managerial than that of their more senior colleagues, it was not more professional, in the classical sense. The newer directors, for example, were less supportive of the social control and representation functions of service organizations, and fewer would have service organizations keep unqualified persons out of museum jobs or represent the field to public arts agencies. Moreover, they were substantially more likely to vest responsibility for enforcement of ethical standards in each museum's board of trustees, while the most senior directors preferred to vest it in the AAM. Finally, the most junior directors also reported a somewhat greater tendency than the most senior (two thirds compared with one half) to act in the interests of their institution when those interests conflicted with those of the museum field.

Has managerial professionalism been increasing in the art museum field? Although a notable minority of more recent entrants were more oriented toward the managerial aspect of their work, they were somewhat less likely to provide traditionally professional responses to questions about collective control and responsibility. At least a minority of the less senior directors, but virtually none of the most senior, apparently held a view of their job that was as similar to that held by performing arts administrators as it was to traditional notions of museum professionalism.

The attitudes of orchestra managers varied less dramatically by cohort than those of the two groups discussed above, but they still showed the same increased tendency toward managerial orientation. Little systematic variation was apparent, however, among CAA directors, for whom each cohort covered far fewer years.

Summary

Did the arts administrators display a "professional orientation" toward their work as managers? The responses elude easy labels. In no field did respondents as a group endorse all the traditional components of the professional belief system. For example, most respondents (except art museum directors) considered management training and education an important role of service organizations, yet they rejected formal management training (and its concomitant credentials) as an important criterion in selecting administrators for jobs like their own. Further, again except for the art museum directors, respondents expressed little interest in the potential of service or professional organizations for collective social control. And, except for the CAA directors, most would act in the best interests of their organizations when those interests conflicted with those of their field. On the other hand, respondents seemed to appreciate the value of collective mobilization to pursue broadly political ends: supporting legislation, negotiating with government agencies, and enhancing public images. In short, the responses of these administrators conformed to the professional model in some respects and diverged sharply in others.

This combination of convergence and divergence was most striking among the art museum directors, whose responses were least like those of other administrators. They placed less stock in formal management training than any other group, both as a criterion for hiring directors and as a function of service organizations, yet they were most supportive of the role of service organizations in establishing (and, for a large minority, enforcing) professional ethical standards. Further, although members of different cohorts in the art museum, theater, and, to a lesser extent, orchestra fields showed a trend toward increasing managerialism, this orientation was reflected in the responses of only a minority of respondents. Among the art museum directors, the increased managerialism was accompanied by a modest decline in support for traditional tenets of professionalism.

Notes

1. *Professionalism*, as it is used here, refers to a set of attitudes and behaviors associated with a distinctive form of occupational organization. It has little in common with the conventional, everyday use of the word as a synonym for *competence* or *qualification*. Thus, whether professional participation and attitudes are associated, either positively or negatively, with competence or effectiveness is an empirical question quite beyond the scope of this study. When some administrators are described as having a "professional orientation" to a greater degree than others, or as "participating to a greater extent in professional activities," these are factual accounts of their self-reported attitudes and behaviors, which should *not* be taken to reflect in any way their effectiveness as administrators.

2. Magali Sarfatti Larsen, *The Rise of Professionalism* (Berkeley: University of California Press, 1977).

3. Alvin W. Gouldner, "Cosmopolitans and Locals: Toward an Analysis of Latent Social Roles I," *Administrative Science Quarterly* 2, 2 (1957): 281-306.

4. Richard H. Hall, "Professionalization and Bureaucratization," *American Sociological Review* 33, 1 (1968): 92-104; William E. Snizek, "Hall's Professionalism Scale: An Empirical Reassessment," *American Sociological Review* 37, 1 (1972): 109-114; Harold L. Wilensky, "The Professionalization of Everyone?" *American Journal of Sociology* 70, 5 (1964): 137-158.

5. Indices of participation were summed to create a composite "professional activism" scale and subjected to regression analysis to assess the relative impacts of several determinants of participation net of one another. These analyses, which are reported in full in the preliminary report of this study, revealed that three factors—operating budget, years of experience, and salary—accounted for most of the explained variation in participation in every field.

5

Attitudes Toward Organizational Missions

To examine administrators' attitudes toward the missions of their organizations and the role of management in accomplishing them, we analyzed data from two sets of questions. Because an organization's board is responsible for policy formation and decisions about goals both in nonprofit organizations and in many public art museums and CAAs, one set of questions asked managers to evaluate the relative importance of 10 characteristics of board members. To answer the question of "What business are we in?" the second set required respondents to choose between pairs of statements reflecting different attitudes toward organizational mission and strategy. Development of questions was guided by ongoing debates within the fields surveyed, and items were revised after review by arts managers, service organization staff, and public arts agency staff.

Board Member Characteristics

Respondents were asked, "In your opinion, how important is the presence of persons with each of the following characteristics to the effectiveness of [your kind of arts organization's] board of trustees?" They were then presented with 10 different items and asked to rank them in importance (see table 5-1). Some items (ability and willingness to donate money; connections with the wealthy, with business corporations, and with government) had to do with ability to give or get resources. Others (willingness to interact with staff, willingness to respect formal hierarchy, and legal or management skills) concerned the board's internal function. Two items (com-

mitment to education and outreach, and representativeness of the community's racial and ethnic groups) reflected concern with pluralism and social goals. And one (personal interest in the arts) was related to the aesthetic mission.

Personal interest in the artistic substance of the organization's work was rated among the top three criteria in all fields by almost two thirds of the respondents. Also prized highly, especially among performing arts administrators, were the ability and willingness to give money, and contacts with business corporations and with the wealthy. Orchestra managers, in fact, appeared to seek "donor" boards that give money and serve as bridges to wealthy individuals and companies. Theater managing directors also emphasized private-sector resource acquisition, albeit with less unanimity. Although art museum directors valued these same income-generating qualities, more than half of them also ranked willingness to respect the museum's formal hierarchy of authority among the three most important board-member attributes. By contrast, CAA directors were diverse in their appraisals, stressing not only contacts with business but also skills, commitment to education and outreach, and contacts with government.

Managers in all fields were much less likely to include among the top three attributes willingness to interact with staff and representativeness of the community's racial and ethnic groups. Similarly, only about one fifth of the performing arts administrators ranked commitment to education and outreach highly, although it did fare better among art museum and CAA directors. And attitudes toward legal and management skills varied widely by discipline, ranked highly by almost half the CAA directors but just one in eight orchestra managers.

Forced-Choice Questions

Most of the forced-choice questions addressed debates or concerns about the extent to which traditional aesthetic aims of arts organizations should be supplemented by partial reorientations: first, toward the market and earned income, and second, toward education and outreach objectives. We sought here to document the administrator's attitudes on these issues, and to see if such attitudes represented relatively coherent ideological positions. Finally, we wanted to assess the relative impact of a manager's organization, background, and career experience on these attitudes toward missions. Note that there is no intention—nor could these data be used—to assess the *validity* of the attitudes.

Respondents were asked to choose between two statements, each reflecting a different position on a management or policy issue. Responses did not necessarily indicate agreement with the statement chosen; respondents

Table 5-1
Three Most Important Characteristics of Board Members, by Field (percent)

Item	Theaters	Art Museums	Orchestras	CAAs
Personal interest in the arts	65.35 (101)	65.00 (120)	65.09 (106)	59.54 (131)
Willingness and ability to donate money	63.73 (102)	70.83 (120)	80.19 (106)	34.35 (131)
Connections with business corporations	58.82 (102)	53.33 (120)	69.81 (106)	58.02 (131)
Connections with wealthy individuals	53.06 (98)	39.17 (120)	53.77 (106)	33.08 (130)
Willingness to respect formal hierarchy of communications	44.44 (63)	56.30 (119)	25.71 (105)	27.91 (129)
Legal or management skills	30.69 (101)	37.50 (120)	12.26 (106)	46.56 (131)
Influence in government circles	32.56 (86)	33.33 (120)	20.00 (105)	39.69 (131)
Commitment to education and outreach	20.43 (93)	32.50 (120)	19.05 (105)	40.31 (129)
Representativeness of community's racial and ethnic groups	17.20 (93)	19.17 (120)	14.29 (105)	29.01 (131)
Willingness to interact with staff at the departmental level	18.18 (98)	10.17 (118)	16.04 (106)	28.46 (130)

NOTES: Characteristics are ranked in order of importance according to the average percent of respondents across all four fields naming each item among the top three in importance.

Figures in parentheses are the number of respondents for each item.

may have agreed or disagreed partially with both options, and in many cases, their personal views were undoubtedly more complex or sophisticated than either one. The value of these questions is not so much in permitting generalizations about what arts managers believed as in enabling us to compare the positions of different managers on several dimensions. In designing the forced-choice options, we tried to present each statement in a contentious tone, as might an advocate of the position it embodied. Occasionally, the tone was softened in an effort (not always successful) to phrase alternatives so as to elicit variation in response.

Most items were designed to counterpose two of three attitudinal orientations—i.e., traditional aesthetic mission, managerialism (emphasis on efficiency and earned income, and orientation to the private sector), and social orientation (emphasis on education and outreach, and orientation toward the public sector)—that were hypothesized to represent somewhat coherent ideological positions. To avoid response-set bias, for those questions in which one statement favored and another opposed a position, "pro" and "con" responses were alternated in the first and second positions from question to question. Since wording of specific items differs from group to group, responses are not completely comparable across disciplines. The principal value of these data are, first, for description of respondents in each field, and, second, for comparison of attitudes across groups within each field. As previously described, responses to forced choices were merged with those to related questions about the difficulty of each choice to yield a six-point scale, ranging from "1" (easy choice of first option) to "6" (easy choice of second option).

Resident Theater Managing Directors

Aesthetic vs. managerial orientation. When asked to choose between a statement favoring efforts to increase earned income and one suggesting that resident theaters are often too concerned with this goal, the vast majority of theater managing directors (88 percent) chose the first. More than half (61 percent) also selected a statement favoring institutionalization to achieve professional excellence over one alleging that institutionalization discourages creativity or innovation. And nearly all respondents (92 percent) favored more businesslike management techniques over a warning that such techniques are inappropriate for arts organizations.

Aesthetic vs. social orientation. More than two thirds agreed with a statement that resident theaters have a responsibility to go beyond their regular programming to educate their audience and potential audience rather than with the opposing assertion that educational programs distract attention from the theater's central artistic task. In another forced choice, more than three quarters of the respondents chose "excellence" over "access"

as a guide to public subsidy. And almost the same proportion selected a statement indicating that resident theaters could expand their audiences to include many more poor, minority, and working people over an assertion that the theater's audience will always be limited to individuals who can really understand and appreciate the dramatic art.

Managerial vs. social orientation. By a strong majority (88 percent), theater administrators favored a statement indicating that resident theaters should look toward business (rather than toward government) for an increasing share of revenues in the coming years. (Shortly before the survey was fielded, the national administration proposed dramatic cuts in the federal arts budget. The salience of this development undoubtedly affected the pattern of response to this question.)

Nonclassified attitudinal orientation. Almost half the respondents favored coordination in planning and programming among arts organizations over a statement stressing the danger to an organization's autonomy of involvement in coordinative efforts.

Art Museum Directors

Aesthetic vs. managerial orientation. Just over half of the art museum directors selected the statement that "art museums have become too concerned with maximizing earned income by mounting popular exhibits of dubious scholarly or artistic value" over one praising art museums for learning to boost earned income by designing exhibits with popular appeal. Approximately 40 percent agreed that museums should use cost-benefit measures in order to be taken seriously by potential patrons, while 60 percent believed such efforts to measure museums' efficiency reflected "a profound misunderstanding" of museum work and goals. Two fifths of the museum directors chose a warning that efforts to use auxiliary activities (e.g., gift shops, restaurants) to increase earned income risk subordinating the museum's artistic goals to commercial ones, while three fifths agreed that museums have a responsibility to exploit commercial opportunities to increase earned income.

Aesthetic vs. social orientation. Almost two thirds of the respondents agreed that art museums should provide thorough interpretation of exhibited works rather than that extensive interpretation interferes with the relationship between the viewer and the work of art. In the forced choice between excellence and access as a criterion for public subsidy, 70 percent of the museum directors opted for the former. And just over half selected the statement that art museums can attract many more poor, minority, and working people over the assertion that museum visitors will always be "the minority of individuals who can really understand and appreciate art."

Managerial vs. social orientation. Fully 86 percent of the directors

agreed that art museums should look to business to provide an increasing share of their revenues in coming years, over an alternative saying the same of government.

Nonclassified attitudinal orientation. More than 60 percent of the art museum directors favored coordination of planning and programming among museums over the warning that such coordination would threaten museum autonomy.

Orchestra Managers

Aesthetic vs. managerial orientation. In response to the assertion that orchestras worry too much about earned income and too little about challenging and innovative programming, 83 percent of the orchestra managers chose a statement praising orchestras for using marketing and programming to boost earned income. And the same proportion favored use of commercial administrative practices, rejecting the notion that efficiency is not what performing arts organizations are all about.

Aesthetic vs. social orientation. The vast majority of orchestra managers (90 percent) selected the statement that ''the orchestra must go beyond its regular programming to educate its audience and potential audience'' over the assertion that educational programs divert attention from artistic goals. Two thirds of them also chose excellence over access as a basis for public support for the arts. And 57 percent believed that orchestras can increase markedly the number of poor, minority, and working people in their audiences, whereas 43 percent believed that the orchestra's audience will always be limited to the few ''individuals who can really understand and appreciate music.''

Managerial vs. social orientation. Almost all (95 percent) orchestra managers chose to look to business rather than government for increased revenues in the future.

Nonclassified attitudinal orientation. More than 60 percent agreed that coordination of planning and programming with other arts organizations represents a threat to autonomy, rather than that such coordination is increasingly necessary in the current fiscal environment.

CAA Directors

Aesthetic vs. managerial orientation. Almost two thirds of the CAA directors chose a statement indicating that CAAs should develop more efficient administrative techniques similar to those of the better-run social service agencies over an alternative statement indicating that arts agencies cannot be run like social service agencies and warning against bureaucratization.

Aesthetic vs. social orientation. Almost four fifths of the respondents

agreed that "CAAs should go beyond the traditional arts to support and encourage" minority and neighborhood arts groups rather than concentrate on the most important and highest quality organizations within their communities. In keeping with this view, almost 75 percent chose access over excellence as a criterion for public support, and almost 90 percent chose the assertion that traditional arts organizations could expand their audiences to include far more poor, minority, and working people over the statement that the audiences for art museums and symphony orchestras will always be limited to the minority who can appreciate great art and music.

Managerial vs. social orientation. The CAA directors were almost as unanimous as orchestra managers (92 percent) in choosing business over government as a future source of increased revenues. Further, more than 70 percent of the CAA directors selected the assertion that CAAs worry too much about getting grants and too little about earning income over the statement that CAAs should provide services to individuals and organizations that are too poor to pay for them.

Nonclassified attitudinal orientation. Again, more than 70 percent supported rather than opposed regional coordination of the planning and programming among CAAs, and more than 85 percent believed CAAs should provide artistic programming that is otherwise unavailable rather than limit themselves to providing support services to other arts organizations.

Summary
Although responses to most items are not comparable across disciplines because of variation in item wording, we can make some rough generalizations. Respondents in all fields overwhelmingly favored statements that future revenues should be sought from business rather than from government. Further, majorities (albeit sometimes small ones) in each field voiced sympathy with the goals of education and outreach, and majorities in all fields except art museums tended to agree with statements supporting improved administrative techniques. The most obvious deviations occurred among art museum directors, who were more likely to choose statements expressing skepticism about or distaste for earned income-producing schemes, and among CAA directors, who alone supported the statement endorsing the principal of access over excellence. Enough variation in response appears, however, that no group's orientation can be characterized as being overwhelmingly aesthetic, social, or managerial.

Variation by Cohort
No major variations by cohort appeared regarding the most desirable qualities for board members, but more differences did emerge in response to statements reflecting attitudes toward organization mission and strategy.

The most senior cohort of theater administrators were somewhat more likely than the most junior cohort (86 to 67 percent) to emphasize excellence over access as a criterion for public support, and they were only about half as likely to choose with ease the statement that resident theaters could greatly expand the number of poor, working, and minority people in their audiences. They were also substantially less likely than other groups (one quarter, compared with almost 40 percent in the middle cohort and two thirds of the newest) to favor coordination of planning and programming among performing arts organizations. As a group, then, the more senior managing directors expressed a somewhat greater commitment to aesthetic values, particularly over social ones, than did their more junior colleagues. But the differences were relatively small.

The more junior art museum directors were approximately twice as likely as their colleagues to endorse the use of exhibits with broad-based appeal to raise earned income rather than deplore such income-earning exhibitions. Similarly, they were considerably less likely (one third of the most junior cohort compared with more than half of the most senior) to choose the statement questioning the use of museum shops and similar means of generating earned income. Support for excellence over access was monotonically related to seniority: more than 80 percent of the most experienced directors, compared with almost half of the least experienced, favored the former. Also monotonically related to seniority were attitudes toward coordination, with just over half of the most experienced cohort— twice as many as the most junior—choosing the statement opposing it. Thus among art museum directors, seniority was associated with favoring an aesthetic over a social and, to a lesser extent, managerial orientation.

For orchestra managers, too, aesthetic views found more favor within the senior cohort than within the junior ones. Nearly one quarter of the most senior managers (compared with just 9 percent of the most junior) agreed that orchestras are often too concerned with maximizing earned income at the expense of the quality of their musical programming. And nearly one third of them (compared with 15 percent of the middle cohort and just 1 of 31 less-experienced managers) agreed that efforts to measure the efficiency of symphony orchestras are inappropriate.

Senior orchestra managers also held aesthetic values over social ones. More than one fifth of them (compared with just 3 of 65 other respondents) endorsed a statement that "educational programs can deflect energy" from the orchestra's central artistic goals, and 85 percent chose excellence over access, compared with fewer than 60 percent of the two more junior cohorts. Like the most senior managers in other fields, those in the orchestra field were also less likely to favor the coordination alternative (just one in four among them, compared with three fifths of the most junior managers). Thus,

in the orchestra field as elsewhere, seniority was associated with support for traditional aesthetic values. In each case, however, it is unclear whether variation by cohort represented a decline in traditional aesthetic concerns over time, a filtering process that screened out administrators with less aesthetic orientations over the course of their careers, or attitude changes associated with movement to larger or more prestigious organizations.

Because of the briefer cohort spans among the community arts respondents, cohort variation in their field was far less marked. Like their peers in the other disciplines, however, the more senior CAA directors were more likely to choose excellence over access than were less experienced CAA directors (more than one third, compared with just over one quarter of the middle cohort and fewer than one fifth of the most junior).

Administrative Orientations and Their Determinants

Although the previous sections described the responses of administrators to individual items and examined how those responses varied among managers of differing levels of seniority, they did not enable us to assess the extent to which the responses cohered into the posited dimensions of administrative ideology (managerial, aesthetic, and social). Nor did they describe the determinants of variation in administrative orientations by examining the net effects of such factors as seniority, organizational budget, experience, and professional participation, controlling for all simultaneously. Our next tasks, then, are to see whether responses to attitude questions cluster in a manner that permits us to identify managerial, aesthetic, or social orientations within the fields surveyed; and, if so, to determine what predicts the extent to which administrators hold such orientations.

Patterns of Administrative Orientation
To pursue the first task, we undertook for each field factor analyses of responses to questions about director attributes, board member characteristics, the "increase relevance and accessibility" function of service organizations, and attitudes regarding organization mission and strategy, as well as to a series of questions about the desirability of different forms of revenues. In the last, respondents were asked to rank in order of desirability 10 sources of income: endowment; admissions; membership; other earned income; private philanthropy; corporate philanthropy; foundation grants; and federal, state, and municipal support. This last set of questions was included because it was hypothesized that a managerial orientation would be disposed toward earned income and corporate aid, while a social orientation would favor public subsidy. As expected, factor analyses yielded meaningful "managerialism" and "social orientation" clusters for every

field. (In part because of the wording of forced-choice questions, aesthetic orientation did not emerge as a third factor.)

Managerialism. The managerialism factor, for all fields, included support for a management rather than arts background for administrators; and for three of the four fields it included both positive evaluations of managerial experience, grantsmanship ability, and ability to prepare a budget as criteria for selecting top administrators, and the forced-choice alternative that favored businesslike and efficient administrative techniques.

In the performing arts, directors' fund-raising ability and marketing experience, in addition to those skills listed above, loaded heavily onto the managerial factor. Among the theater managing directors, desirability of admission revenue loaded positively and desirability of municipal revenue loaded negatively onto managerialism. Among directors of orchestras and art museums, forced-choice preference for business support in the long term loaded on managerialism, as did desirability of membership revenue among orchestra managers and forced-choice support for income-earning exhibitions and ancillary activities among art museum directors. Federal support, on the other hand, bore a negative relationship to managerialism among the art museum directors.

Among the orchestra managers, three director attributes loaded *negatively* on the managerial factor: knowledge of classical music, commitment to education and outreach, and standing in the field. Thus, this factor represents not just support for efficiency but also some opposition to aesthetic or social goals. By contrast, for the CAA directors, the managerial factor was associated with a rejection of earned income, particularly endowment and other earned income, as revenue sources.

Social orientation. For each field, the social orientation factor included high rankings of educational experience and of commitment to outreach as criteria for selecting top administrators; of commitment to education and outreach as a desirable attribute of board members; and of increasing relevance and accessibility as a function of service organizations. For three of the four fields, grantsmanship as a criterion for selecting a top manager and support for access over excellence loaded on this factor as well. The social orientation factor was most similar for theater managing and art museum directors: for each group, it included (in addition to the variables shared with other fields) agreement that the minority, poor, and blue-collar audience could be greatly expanded, and a preference for federal, state, and municipal support. For art museum directors alone, it was associated with relatively low ratings for endowment income; and for theater administrators alone, it included a preference for foundation assistance.

Among orchestra managers, social orientation was associated with high ratings for fund-raising ability and standing in the field as director-selection

criteria, in addition to the common variables mentioned above. Among CAA directors, it was associated positively with appreciation of the arts as a criterion for choosing executives, support for grants to neighborhood and minority arts organizations, and support for artistic programming by CAAs. (The two latter measures are from forced-choice items asked only of CAA directors.)

Among the art museum and CAA directors, two other interpretable factors emerged. For the former, the third dimension represented a kind of private-sector market orientation reflecting opposition to conventional aesthetic values. For the latter, the third factor represented an extreme public-sector orientation, involving a strong rejection of the market and of earned income.

Predictors of Administrative Orientations

To examine the net effects of background, career experience, and other factors on the extent to which administrators expressed managerial or social, rather than more conventionally aesthetic, orientations in their responses, we used regression analysis. Scales were developed for both managerial and social orientations by standardizing and summing respondents' scores on each variable that loaded on the relevant factor at .30 or above. The models reported here include those independent variables that had a notable impact on orientations, or the omission of which altered the coefficients of other predictors. In addition, budget size and a measure of seniority were included in all regression equations as independent variables.

Managerialism. The regression models predicting the degree of managerialism were quite successful (given the subjective nature of the measures on which the dependent variable was based) in all but the community arts field, explaining between 34 and 44 percent of the variation in managerialism among theater, art museum, and orchestra administrators. Among both art museum directors and the orchestra managers, managerialism was strongly and negatively related to seniority, controlling for other predictors. Among the former, budget size also had a notable negative effect, whereas among the latter, women were, other things equal, more managerial in orientation than men.

Managerialism was negatively related to measures of family background and educational experience among the art museum directors and orchestra managers, and positively related among the CAA directors. Parents' educational attainment was a strong negative predictor of managerialism for the art museum directors, while the quality (Astin score) of the college from which a manager graduated had a similar impact among orchestra managers. By contrast, having attended a private school was the strongest predictor of managerialism among the CAA directors.

Among theater administrators, a high degree of managerial orientation was predicted by three variables: a degree in business or management; prior work experience in resident theater marketing, development, or public relations; and *no* prior work experience as artistic directors, actors, or technicians. Career-experience variables were also strong, albeit negative predictors of managerialism among art museum directors, who were far less likely, other things equal, to score high on managerialism if they had earned a Ph.D. in art history or had ever held a professorial appointment. By contrast, career experience had no important effect on the scores of orchestra managers or CAA directors.

Controlling for other factors, professional participation (based on the number of professional activities in which a respondent reported taking part) had a strikingly positive impact on managerialism in every field but the community arts. This was true even among art museum directors and orchestra managers, for whom the simple correlations between managerialism and participation were close to zero. What these findings mean is that the factors that predicted participation were different from and to some extent opposite to those that predicted managerialism; but that if one controls for these factors, directors who are more active in their professional field are more likely to express managerial views than would be less active managers with similar backgrounds and experiences.

Social orientation. Among theater managing directors, social orientation was positively related to seniority, negatively related to private school enrollment and parents' social class, and very negatively related to organization budget.

By contrast, the social orientation scores of art museum directors were unrelated to museum budget size and were negatively related to seniority. As in the case of the theater managing directors, however, having attended a private school and, to a lesser extent, parental social class and educational attainment, again were negative predictors. Finally, the most important negative predictors of social orientation among art museum directors were a Ph.D. in art history and experience as a professor, two factors that also exerted a strong negative effect on managerialism and would seem to be associated with a strongly aesthetic conception of the museum's role. On the other hand, the strongest and most significant positive predictor of social orientation among this group was participation in professional activities.

The social orientation scores of orchestra managers were predicted largely by just three variables: holding other factors constant, social orientation was stronger among women than among men and, to a lesser extent, among managers with many years of experience in the orchestra field, and it was weaker for managers with prior arts experience.

The social orientation of CAA directors was unrelated to their organizations' budgets and to their seniority. Indeed, the only important predictor was their college's quality score: directors who had attended selective colleges were less likely, other things equal, to score high on this scale than others. By contrast, women directors had higher social orientation scores, other things equal, than men.

It should be noted that variation in scores on the managerialism dimension were explained largely by adult educational and career experiences, whereas scores on the social dimension were largely influenced by family background or gender in every field.

Conclusion

Administrators' responses to attitude questions about management and priorities of arts organizations clustered together in groups that reflected managerial and social orientations. The former emphasized efficiency and market standards in the governance of arts organizations; the latter emphasized education, outreach, and public-sector responsibility. Each orientation opposed, to some degree, more traditional aesthetic views, which stress both the role of arts organizations in supporting scholarship, preservation, and opportunities for innovation; and the importance of maintaining the autonomy of the arts from the demands of the market for efficiency on the one side, and of the public for relevance or service, on the other.

In all fields but the community arts, the analyses indicated that this aesthetic perspective was more closely held by senior administrators, while younger managers were more likely to express social or managerial views. If this finding reflects stable differences among cohorts (as opposed to the effects of aging on attitudes), managerialism will probably increase in the performing arts and museums in the coming years. For the theater managing directors, for example, managerialism was negatively associated with having production experience, which fewer managing directors now possess. By the same token, it was positively associated with holding a business degree and having prior experience in marketing, public relations, or development—both of which are apparently becoming more common. And it was also positively associated with professional participation, which suggests that, other things equal, administrators with managerial perspectives are likely to play influential roles in their fields as a whole.

Similarly, among the art museum directors, managerialism was negatively associated with years of experience but positively associated with participation. To the extent that young directors with managerial perspectives are more active in the art museum community, their orientations are likely to spread. Nonetheless, the increased percentage of directors with

81

Ph.D.s and professorial experience—both powerful negative predictors of managerial perspectives—may represent a strong countervailing force in this field.

By contrast, the regression analyses provided little reason to expect change in the social orientation of performing arts administrators. Yet among art museum directors, professional participation exerted such a strong positive effect in this regard that we might expect orientation to the museum's educational mission to increase over time. Again, however, the strongly negative effects of a Ph.D. in art history and professorial experience could exercise a countervailing force. Indeed, if the museum's historical alternation between education and connoisseurship is any guide, we can expect aesthetic and social orientations to continue to coexist in American art museums for many years.

Index

A

Administrative assistants, women as, 17

Administrative orientations, 75, 77-81

Administrators, age of at first executive position, 3; appreciation of art or artists managed, 61; attrition of, 4, 7, 37; autonomy as source of satisfaction for, 31; certification of, 41; college background of, 2; and contact with works of art, 8, 31; criteria for selection of, 61; education of, 2; and jobs outside the arts, 4; qualities of, 61; recruiting of and stable career paths, 4; salaries in arts organizations, viii; sources of satisfaction for, 29-31

Aesthetic aims of organizations, and market concerns, 70

America, first art organization in, ix

American Art Directory, ix, x

American Arts, 56-57

American Association of Museums (AAM), ix-x, 63; ethical standards of, 66; meetings of, 54, 55, 56, 58

American Council for the Arts, 54, 56

American Symphony Orchestra League (ASOL), ix, 54, 55, 56, 59

Art Bulletin, 56

Art Journal, 56

Art museum directors, 12; and accreditation for museums, 65; and administrative programs, opinions on, 50; administrative training for, viii, 66, 75; aesthetic vs. managerial or social orientation, 73; age at becoming executive, 20; age cohorts, 5, 16, 37; age and leaving field, 38; age of women as, 13; apprenticeship for, 59; associate director for administration, viii; attrition among, 4; budget correlated with university attended, 27; business rather than government help sought by, 74; cohort differences among, 66; connoisseurship and contact with trustees, 36, 38; and contact with artists and works of art, 31; coordination of planning and programming among museums, 74; dissatisfaction with contacts with government agencies, 31; effect of education on salary for, 8, 28; entry pattern for, 1, 2, 3, 17-18; ethical standards of, 63; and formal education, 2, 15; and government relations, 5, 31; and jobs outside the arts, 38, 43-44; and management training for, 21, 43-44, 67; managerial vs. social orientation, 73-74; more satisfaction in smaller institutions for, 33; and need for artistic background, 63; and non-art business, 21; noneconomic career rewards, 25; on-the-job training, 44-45; and organizational budgets, 3, 27; parents of, 15, 16, 27, 28; periodical reading by, 58; preparation of, 5, 42-44; private secondary school attended, 14, 39; professionalization of, 23; public relations for, 5; salaries, 25, 28; scholarship interests of, vii; selective college attendance by, 12; of small museums, 58; today vs. the 1930s, viii; training for senior cohort, 5; and university teaching salaries, 25; unprepared for

B

C

U

T

V

W

Y

PAUL DIMAGGIO is executive director of the Yale Program on Non-Profit Organizations and also associate professor in the Department of Sociology, in the School of Organization and Management, and in the Institution for Social and Policy Studies at Yale University. He has written widely about arts organization and cultural policy and is editor of *Nonprofit Enterprise in the Arts: Studies in Mission and Constraint*. He is currently writing a book on the social organization of the arts in the United States from the Civil War to the present.